Future Present is based on the Design Council's Millennium Products initiative
Full details are available on: www.millennium-products.org.uk

Written and edited by Nick Skeens and Liz Farrelly

Art direction by Angus Hyland, Pentagram Design
Design by Russell Hrachovec, Pentagram Design

Photography by Lee Funnell, Graphicphoto,
assisted by Emma Poyser

Illustrations by Akio Morishima and Kelsey Finlayson

Sub-editor Helen Cleary

New Millennium Experience Company (NMEC) logo ©1998
Millennium Products logo is the registered trademark of the Design Council

Additional photography courtesy of: Edmund Clark (p6-7); Core Design Limited™ with Dome image by Sham/New Millennium Experience Company (NMEC) (p126-127), Foster and Partners, Architects, Designers and Planners (p102-103), Guzelian (p152), Image Bank (p104-105), Richard Learoyd (p119, 134-135), Magnum (p14), Toby Peters (p193), Vinca Petersen (p62-63), QA Photos Limited/NMEC (p87), Neil Ray and Mott MacDonald (p170), Mandy Reynolds (p82-85), Rolls-Royce plc (p172), Tony Stone Images (p44), Trevor Burrows Photography (148-149), Gregg Virostek (p68), Keith Wilson (p174)

Cover model, Courtney Kyriakou De'Ath

First published in 2000 by Booth-Clibborn Editions Limited,
12 Percy Street, London W1P 9FB
info@internos.co.uk
www.booth-clibborn-editions.co.uk

Printed and bound in Hong Kong

ISBN 1-86154-146-5

FUTURE
PRESENT

IT JUST TAKES ONE GOOD IDEA

FOREWORD

BY **JOHN SORRELL** CBE
CHAIRMAN, DESIGN COUNCIL

What better time to celebrate innovation than at the dawn of a new age? That was the idea behind the Design Council's Millennium Products initiative – to identify and celebrate the most innovative products and services created in Britain during the last five years of the outgoing millennium. Their creators point the way into the future in the great tradition of British pioneers of the past who showed the way forward at key moments in time.

The new millennium began at 00.00 hrs GMT, on the meridian line which runs through Greenwich, thanks to the astounding achievements of Britain's Astronomer Royal Nevil Maskelyne and John Harrison's famously accurate clocks. The setting of longitude was of immense importance to world trade and prosperity, and accelerated the communications revolution.

Britain's heritage in innovation and creativity is well known. Once the workshop of the world, it was the UK which kick-started the Industrial Revolution. Seventy per cent of the world's most significant inventions were created here.

We have won 90 Nobel prizes for science. We invented the television, telephone, world wide web, and discovered a whole host of medical breakthroughs, from penicillin to Viagra.

As the world's focus turns to Greenwich, the Design Council has been gathering evidence of Britain's resurgence as a thriving, creative country.

Future Present demonstrates the extraordinary diversity of British talent at the end of the twentieth century. It gives brilliant examples of inventiveness, creativity and design. It tells the amazing stories of endeavour, passion and commitment behind the products which give unique insight into the power of entrepreneurial spirit.

The Millennium Products described here are making a difference to people's lives right now. We hope this book will encourage everyone everywhere to be innovative and that it will inspire people around the world to create a better future.

MILLENNIUM PRODUCTS

JUST WHAT ARE MILLENNIUM PRODUCTS?

BY **ANDREW SUMMERS**
CHIEF EXECUTIVE, DESIGN COUNCIL

"Ask yourselves: is this product innovative? Is it forward-thinking? Does it solve problems? Is it pioneering? Is it something we can feel proud of or inspired by?"

Those are the questions we posed to the judges who evaluated potential Millennium Products. Our judging panels, drawn from over one hundred experts in technology, science, design, business and the arts, met regularly from early 1998 to the end of 1999. It was their job to decide which of the many thousands of products and services submitted by companies across the UK could match up to those questions.

Millennium Products status has meant a great deal to hundreds of companies, both by boosting morale and by generating interest in the market place. Some Millennium Products have been featured in exhibitions around the world, organised with The British Council and the Foreign and Commonwealth Office.

The names and images of Millennium Products are represented on a landart installation called Spiral of Innovation at the Millennium Experience in Greenwich.

The Millennium Products initiative recognises innovation from all quarters. So whether you are Rolls-Royce producing the breathtaking Trent jet engine or two firemen from London creating a unique DIY solution, your originality is recognised, your idea encouraged and your genius offered as an inspiration to others. It has been immensely inspiring for all of us at the Design Council to discover so many examples of creative brilliance. It is equally inspiring to know that this book represents just one part of the total creative output of British business and industry today.

Millennium Products will live on beyond this book, the Dome and the world-wide exhibitions in a Design Council project called Sharing Innovation. This unique resource features the stories behind each Millennium Product and will make them available to all via the internet. Sharing Innovation will encourage others to have the confidence in their ability to innovate and exploit to the maximum their creative skills.

Because, as we turn to face the new millennium, it is our own creative and innovative abilities which will serve us best in the future.

CONTENTS & DISTRIBUTION

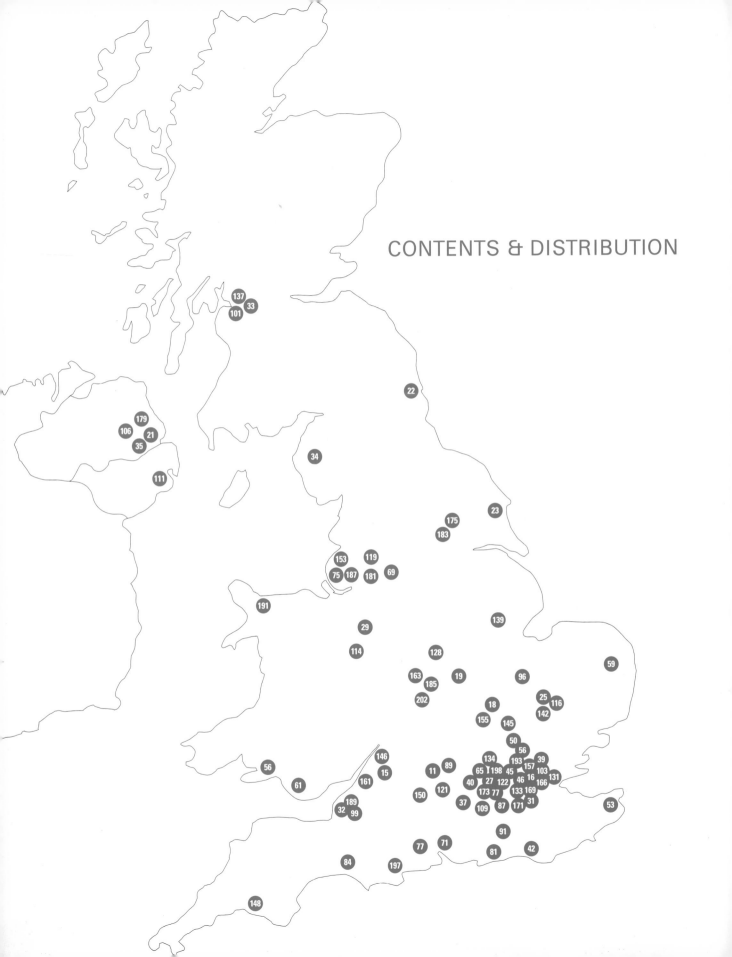

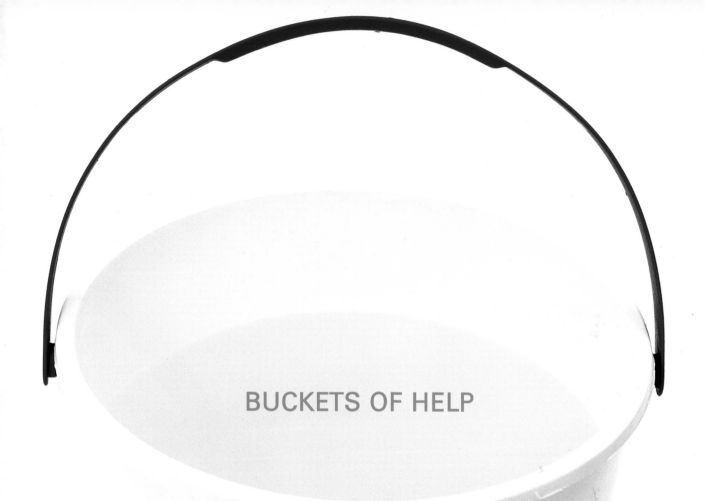

BUCKETS OF HELP

SE

**OXFAM STACKABLE
WATER CARRIER**
DESIGNED FOR A PURPOSE

OXFORD OXFAM GB

A bucket as a Millennium Product! Whatever next? Well consider this: you run an aid agency in Kosovo and thousands of refugees arrive in the camp; there are two standpipes supplying water; how do you distribute it to the people? Or you are in a village in Africa hit by drought; you locate clean underground water away from the village and dig a well; how do you get the water to the village?

Until now the answer would have been the plastic jerrycan, complete with screw-on cap. Except the screw-on cap often gets lost. And have you tried cleaning the inside of a jerrycan? And what about transporting them to a disaster area? They're light, but they take up so much space that you're transporting more air than jerrycan. And have you ever tried carrying a full one on your head, or even in your hand – the handle is often uncomfortably small and awkward?

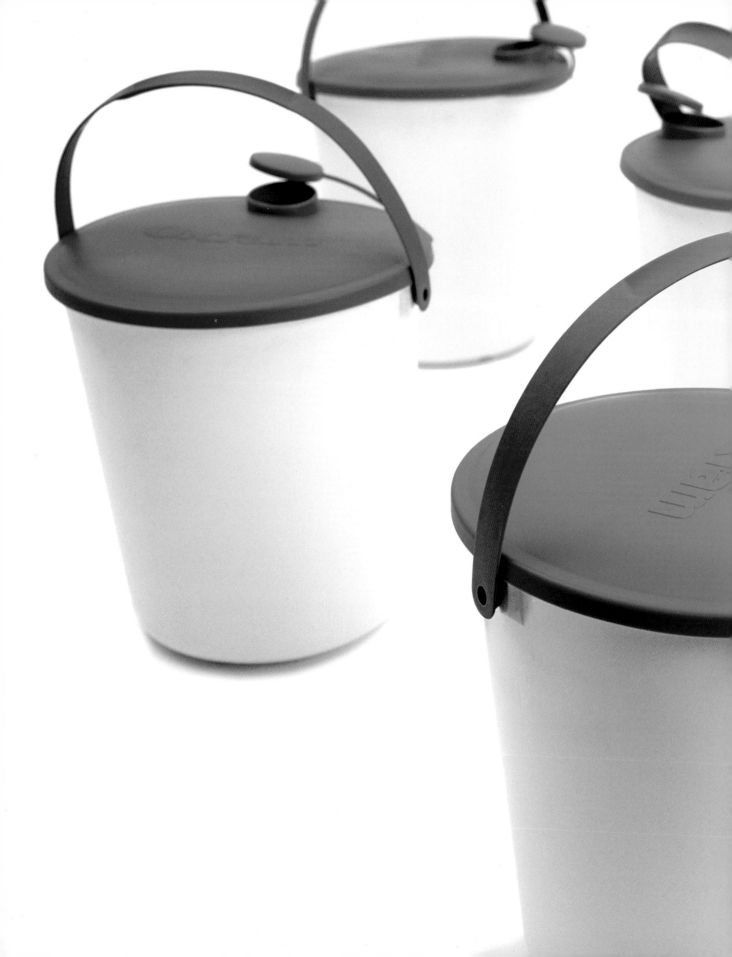

Enter the Oxfam bucket, developed by Core Plastics Limited. It's made of durable, lightweight UV-resistant plastic, and you can stack 180 of them in the same space where you can cram just 40 jerrycans. That means more water can be carried and more lives may be saved per plane payload. The bucket has a snap-on water-tight lid that is difficult to take off and is usually only removed for cleaning. A smaller spout is set into this lid for pouring and filling. This is covered by a cap that's easy to remove but is secured by a strip of tough plastic. The bucket is designed to be carried by the hoop handle but also features a specially-shaped bottom to facilitate head-carrying with minimum spinal impact.

Suzanne Ferron, one of Oxfam's Emergency Support People in the field, comments on the Oxfam bucket's use among refugees in Sierra Leone: "This bucket is a very basic but also a vital piece of equipment. If you are fleeing for your life, large water containers are not uppermost in your mind as essentials, and are likely to get chucked away in favour of food and clothes. We had sourced clean water but then had to distribute the Oxfam bucket when hygiene problems arose with the water containers already on site. The lid and spout stop people using contaminated cups as ladles – that can spread disease quickly. It was great to be able to get so many of the hygienic buckets into the region so quickly. Clean water prevents the two scourges of refugee camps – diarrhoea and typhoid fever."

WIND UP MERCHANT

SW

WIND UP FREEPLAY® RADIO
REVOLUTIONARY CLOCKWORK
MECHANISM SAVES LIVES

FREEPLAY ENERGY EUROPE LIMITED

The clockwork radio has become an international ambassador for British innovation of the garden shed variety, and Trevor Baylis's difficult path from concept to production is a classic story of battling against the odds. But if Trevor had owned a television remote control, there would never have been a clockwork radio.

Trevor Baylis: "It was the best time of my life and the worst time of my life. I happened to be watching a TV programme about the spread of AIDS in Africa. Not through choice – if I could have been bothered to get out of the chair, I'd have switched over. I found the horrendous scenes of this poor guy dying on a mat in a hut too dreadful to watch. But the next pictures, showing the man's parents being dumped down an open grave stopped me on my journey across the room. The narrator said that the spread of AIDS could be dramatically slowed if only people heard how to avoid it. But with low literacy, little electricity and radio batteries being at a premium, the message simply wasn't getting through."

"This was my Eureka moment," recalls Trevor. "I stepped through to my workshop, with the narrator still talking in the background, picked up a battered transistor radio and soldered the battery connectors to an old DC electric motor, which, I knew, worked as a dynamo when run in reverse. I then jammed the motor in the chuck of a hand-drill where the drill-bits are usually held, gripped the handle in a vice and turned the drill's wheel. The dynamo turned, generated electricity and the transistor radio burst into life. This all happened before the final credits rolled."

Then it was a long and hard road from prototype to production. "The worst thing was the abuse," states Trevor. "I must have gone to hundreds of companies, and almost all of them treated me like I was an idiot. I don't mind anyone looking down on me as long as they don't expect me to be looking up. Finally I took all the rejection slips, threw them up in the air, and decided to seek some publicity."

After contacting the BBC World Service, a sympathetic producer put Trevor in touch with *Tomorrow's World*. They ran a feature on his invention after which he was contacted by a mergers and acquisitions specialist who helped get the product to market. The clockwork radio has now been adopted by the United Nations and is selling over 120,000 units a week around the world.

WIND UP FREEPLAY® RADIO:
ALTERNATIVE POWER SOURCES

1. CLOCKWORK
B-MOTOR TEXTURED CARBON STEEL SPRING, DRIVING A DC
GENERATOR THROUGH A TRANSMISSION, APPROXIMATELY
60 TURNS PROVIDES FULL ENERGY STORAGE

2. SOLAR
HIGH PERFORMANCE THIN AMORPHOUS FILM SOLAR PANEL
WITH A 3.0V 50MA OUTPUT

PROPELLED INTO THE FUTURE

EMid

CORBY, NORTHAMPTONSHIRE

AMAZON AQUACHARGER
MINI WATER-POWERED
GENERATOR

MARLEC ENGINEERING COMPANY
LIMITED

It's said that the best ideas are simple, straightforward ways of improving the quality of life. That's the very stuff of Millennium Products…

If you live in a village in a South American rain forest, what is your most vital need? Food? The jungle is replete with nutrients. Water? It flows in abundance. Entertainment? Everyone likes to be entertained. So why do South American villagers make a day's walk into the nearest town carrying heavy "deep cycle" batteries, leave them there to be recharged, and return the following day to pick them up, only to go through the whole process again a couple of days later? For two reasons – lighting (vital in the persistently long nights of tropical climes) and television, powered by a 12-volt battery.

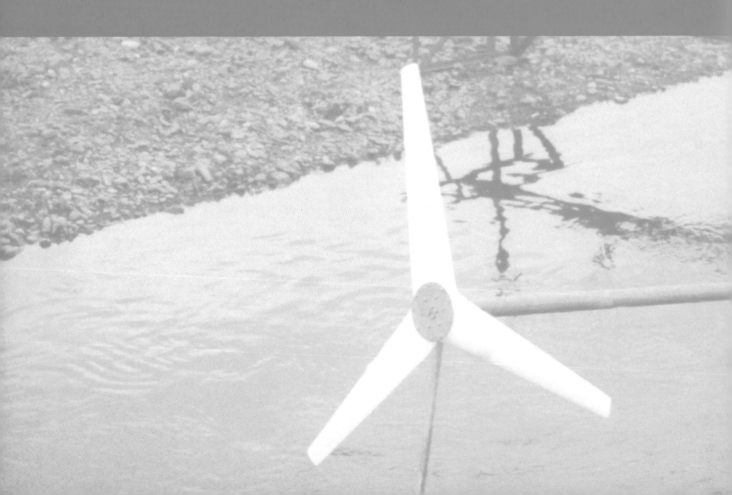

PROVIDING UP TO 500W OF POLLUTION-FREE POWER CONTINUOUSLY WITHOUT THE NEED TO BURN FUEL

Electricity is just as important in the developing world as it is elsewhere. And research consultant Peter Garman, who has developed some ingenious water-driven water pumps for irrigation on the Nile, recognised the need for low-voltage power in riverside villages on a recent trip to the Amazonian headwaters in Peru. The result? He invented the Amazon Aquacharger. This device converts the power a flowing river directly into electricity.

Peter explains: "An alternator sits in a 12-foot-long open boat anchored in the current or moored to a jetty. A three-metre-long prop shaft sticks out the back of the boat driving a 1.8 metre propeller. The river flows, the turbine spins, the prop shaft rotates, fish make a sudden detour, the alternator hums and power flows down a cable to a control unit in the village. Villagers can charge six batteries at once for free, for ever. If heavy rain makes the river flow too fast, the prop automatically lifts out of the water and stops."

Peter took the idea to Marlec, famous around the world for producing renewable energy products – they specialise in windmills. Marlec immediately recognised its potential for providing communities and aid agencies with a reliable power source for low-voltage emergency equipment, such as water purifiers and vaccine fridges. Currently the Aquacharger is undergoing field trials in Peru, Columbia and Sudan.

THINKING THE UNSINKABLE

NI **MARIN-ARK**
SUPER-SAFE LIFERAFT SYSTEM

BELFAST RFD LIMITED

Imagine for a moment that you are on a passenger ship which is sinking fast. The lifeboats have already been deployed and you face a 50-foot leap into freezing water in a howling gale. An inflatable lifeboat rolls in the waves below; it is upside down. You have two terrified children with you. You already know, as they do, that you probably aren't going to make it.

Imagine now that you are on the same sinking passenger ship, but it is equipped with a state-of-the-art liferaft system. You don't leap over the side. Instead you and your children climb into a cylindrical telescopic escape chute that automatically adjusts for the lift and fall of the waves. You slide straight into a 100-person inflatable liferaft that cannot be turned upside down because it's internally symmetrical. You don't even get wet. Congratulations, you have been evacuated by a Millennium Product.

The Marin-Ark evacuation system was born in the wake of such tragedies as the Estonia disaster in which many

people died in freezing Baltic waters clinging to capsized rafts. A ship with four Marin-Ark evacuation stations is capable of safely accommodating 1,600 people in less than 18 minutes. The Estonia, with its bow doors breached by the seas, rolled over and went down far faster than that, but, had it been equipped with the new system, many more people could have survived. Even though Marin-Ark liferafts may be pushed under by the capsize they will automatically blast free of both the ship and their escape chutes before popping up to the surface, fully inflated, and the right way up.

Peter Rea, RFD marketing manager: "This has been an incredibly successful product for us. You'll now find Marin-Ark on around 20 vessels from Norway to the South Pacific. The new 2,000-passenger P&O cruise ship, Aurora, is fitted with them. Sea France's cross-channel ferries, Renoir and Manet, also have Marin-Ark, and so does the Commodore Clipper which runs between the UK and the Channel Islands."

MAKING THE MOST OF A WASTE OF BREATH

AIRPOCKET & AIRPOCKET PLUS
LIFE-SAVING BY RE-BREATHING

**MORPETH,
NORTHUMBERLAND**

SHARK GROUP

For how long can you hold your breath? Thirty seconds? If you can hold it for 30 seconds, you can hold it for over a minute. How?

Try this at home. Take a plastic bag, such as a sandwich-bag. Then take a plastic tube. Put the tube in the bag and hold the bag closed around the end of the tube. Sit down and take a deep breath. After 30 seconds or so, or just when you can't bear it anymore, breathe out through the tube into the bag. Then breathe back in again, through the tube. And carry on breathing your own air in and out of the bag. As soon as you feel at all uncomfortable, stop.

You have effectively survived on the same breath of air for between two-and-a-half to three-times longer than you could normally. How? Because when you inhale, you only consume four per cent of the oxygen in your lungs. From one point of view, breathing out is actually a waste of good, usable oxygen.

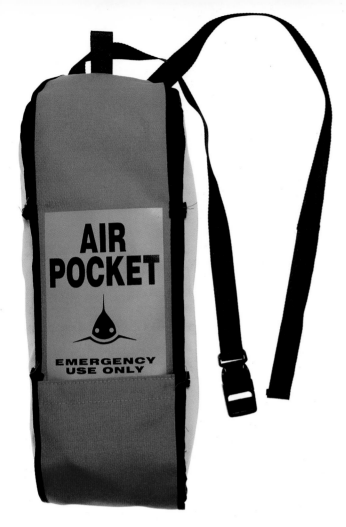

This little trick – which should only be attempted in company in case you feel at all faint – is the basis of the Airpocket. Diving physiology expert Professor David Elliott brought the idea to Shark as part of an initiative by the exploration and production division of Shell. He had illustrated one of his books on diving medicine with a picture of an ancient Greek diver with a sheep's bladder in his mouth. He asked: "Can you turn this into a survival product?"

Shark technical manager, Tom Maddern: "The main problem is hydrostatic pressure. It's all very well trying this sitting at your desk. But when you're underwater it doesn't work too well. So I did some maths and came up with a design that allows people to re-breathe their own air untrained, underwater and in emergency conditions."

Now imagine this. You are in a helicopter that is ditching into the sea. You have a minute to get out before the helicopter takes you down – it means you'll be moving underwater for at least 30 seconds. But when the water rushes in it's freezing cold. You experience "cold shock" and are unable to catch your breath, much less hold it for half a minute.

"The great thing about this device," says Tom, "is that it allows people who can only hold their breath for a couple of seconds to survive underwater for nearly 60. The CO_2 build-up also calms cold shock rapid breathing and so helps to reduce panic. That's why 6,000 of our units are aboard North Sea helicopters and some light aircraft. Now we've developed Airpocket Plus, which includes a back-up air canister in case no breath can be taken at all, and we're also working on versions for passenger aircraft."

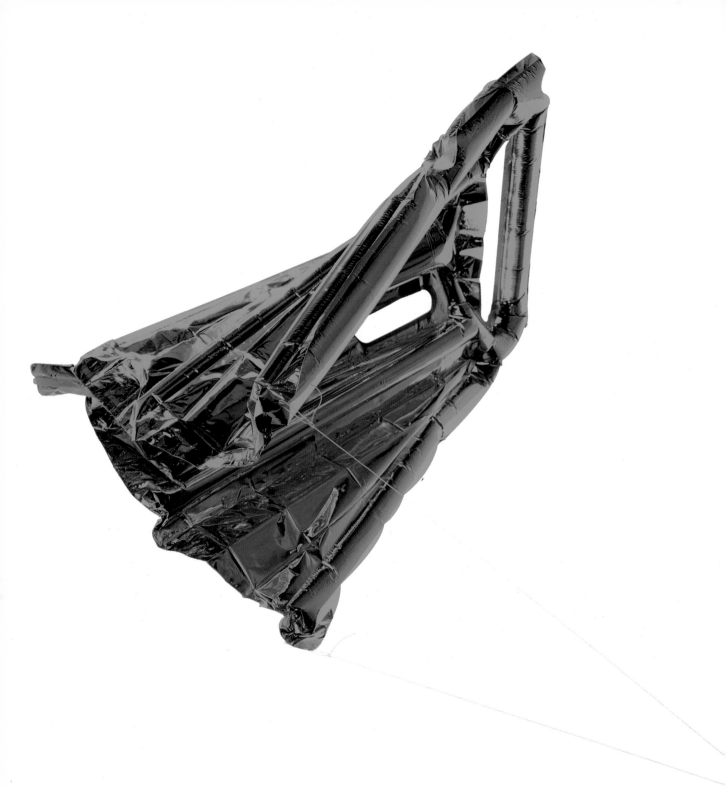

HELPLINE

ACTUAL SIZE

SE

SKYSTREME
INFLATABLE EMERGENCY LOCATOR

BRENTFORD, MIDDLESEX

SKYSTREME UK LIMITED

What could be more frightening than being lost in a wilderness of mountain or moor terrain? Except, of course, being both lost and injured. It could happen to anyone rambling through the world's beauty spots. A slip, a tumble, and suddenly you need help but there is none to be had for miles around.

Which is why Vernon Pascoe and Bernie Hanning invented Skystreme, an inflatable, radar-reflective, visual location marker that folds out from a tiny pocket-sized pack (weighing 43 grams) to become a flying beacon on an 80-foot-long string.

Bernie Hanning: "It's basically an inflatable plastic wing which has a mirror-bright covering that can be spotted from miles away. You inflate it, throw it into the air, and the lightest of breezes will lift it high above you. This gives searching aircraft a much better chance of spotting you, both visually and with radar. Also, if you are using it at night and there's a wind of at least 10 mph, it can lift 'light sticks' high into the air."

The secret of this kite-in-a-pocket lies in its aerofoil design. "We were originally trying to produce a flying beacon using lighter-than-air gases," says Bernie. "The only trouble with gases is that if they are in a tethered balloon, wind can push them down because air is heavier. It's a bit like waves washing over a buoy anchored on a short chain. Plus they need expensive cylinders in order to inflate. All sorts of ideas were going around in my brain during those days, my experience as a paraglider, the way the wing above me inflated, the materials we could use....Then came the Eureka moment, when the jigsaw pieces fell into place. I called up Vernon and said, think of inflated washing-up gloves with webbed fingers! He didn't know what I was on about."

He was on about a breath-inflated wing, and it was a breakthrough. Now this half inch-thick package the size of a credit card is being used by NATO military in a variety of forms. In March 1998 an Italian explorer making a solo attempt on the North Pole was picked up after his Skystreme was spotted from the air. He'd been given it by a couple of Royal Marines who'd also abandoned their mission.

Coincidentally, Skystreme has a number of other related uses, for instance, as an inflatable emergency splint (sold around the UK as such by SP Medical Services of Telford), and as a thermal barrier vest offering protection against hypothermia. This application is also being developed as a separate product.

So next time you take a tumble in the wild, break your leg and have to wait for help in the freezing cold, no doubt you'll be wishing you had three Skystremes in your pocket.

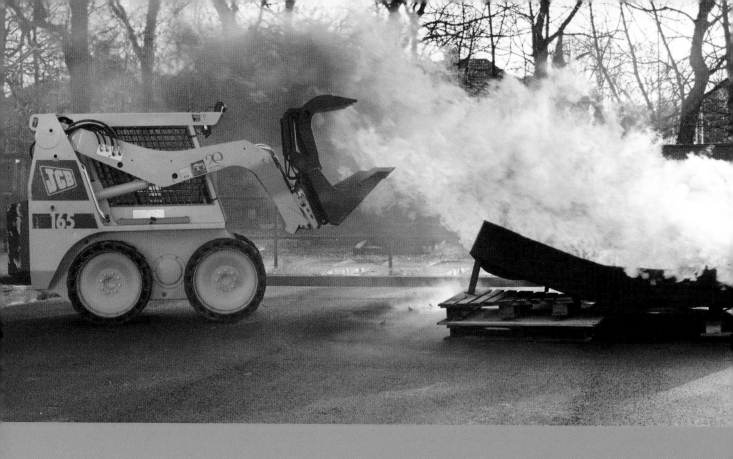

FIRESPY IS GO

WMid

FIRESPY
ROBOTIC FIRE-FIGHTER

JCB SPECIAL PRODUCTS LIMITED

A fire breaks out in a paint store. It quickly gets out of control. Forty-five-gallon drums of chemicals are close to the blaze, and the fire-fighters can't get anywhere near it. The building's structure is threatened and the fire is spreading.

Start *Thunderbirds* music. Enter, rather dramatically, JCB's Firespy, the world's first remote-controlled fire-fighting machine. Immune to the flames, the bulldozer-sized robot clears a path through the debris, picks up the drums one by one with its metal claws, and carries them away from the blaze. Lives aren't risked. Property is saved. FAB.

The secret to Firespy lies in the high manoeverability of its skid-steer system and its remote controls. Len Sambrook, robot business unit manager at JCB: "It's not rocket science. All we've done is taken the driver out and put in an RC (remote control) unit that's in common use on cranes. But the wonder of this machine is that if you have

a car in the entrance of a blazing garage, Firespy can pick it up and get rid of it. If a fire is heating up hay bales or gas cylinders, the fire officer doesn't have to think about committing a human officer, he sends in the robot."

Like every piece of science-fiction gadgetry, Firespy comes equipped with an extra, thanks to development work by West Yorkshire Fire Brigade. They've come up with the transport truck which deploys the three-ton Firespy, and carries the claws, hooks and fire hose attachments. Says technical services manager Noel Rodrigez: "Firespy is equipped with cameras packed with a heat-resistant foam, which, if it gets too hot, melts and solidifies around the electrical circuitry, protecting it from the blaze. The cameras are further protected by a fire jacket that can withstand 1,000°C. All in all the Firespy is an extremely impressive piece of safety equipment."

SE

SEVENOAKS, KENT

FIREANT
LANDMINE CLEARER

DERA

Each day the curse of landmines is visited upon people around the world. Each day people are killed or maimed as they walk or drive over a landmine, or try to disarm one. DERA, the Defence Evaluation and Research Agency, has at last come up with what could be, if not a total solution, then a significant step towards one.

Trevor Griffiths, DERA technology leader for pyrotechnics: "Until now the most common way of dealing with a landmine has been to detonate it with a controlled explosion. But this can be very dangerous, and the explosives used to do the job are of value to criminals as well as being difficult and dangerous to transport. Learning to diffuse a landmine takes a lot of training and people are still killed doing it."

"So we came up with FireAnt, which is effective against most anti-tank and anti-personnel mines," continues Trevor. "Basically, FireAnt incinerates the mine with almost

no risk of detonation. The great added bonus is that it requires minimal training to use, so minefields and other unexploded ordnance can be cleared more quickly by more people. All you do is place the FireAnt next to the mine, aim it, without touching the mine itself, press the firing button, and a 1500°C flame roars out of the end of the Ant and melts the mine, say, a small anti-personnel mine, in about 20 seconds flat. The mine is completely burnt out – usually there's very little left at all. It's a simple idea to help rid the world of a terrible menace."

FireAnt is safer to use, transport and store than explosives, and is easier and quicker to set up. It's being manufactured by Pains Wessex who say that the system is cheaper than existing explosive-based mine clearance systems and production is already underway. Cheap means affordable and plentiful, and that's just what's needed in order to deal with the estimated 100 million unexploded landmines now littering the planet.

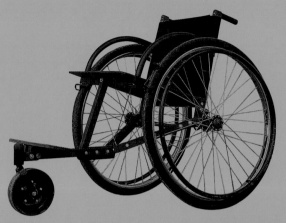

REINVENTING THE WHEELCHAIR

SW

BRISTOL

THE MEKONG WHEELCHAIR
RUGGED RURAL VEHICLE

THE MOTIVATION CHARITABLE TRUST

Why build a three-wheeled wheelchair out of wood? Surely it's just another incarnation of the errant-thinking which prompted that tippy three-wheeled invalid vehicle.

Simon Gue, a founding director of the Motivation Charitable Trust: "Three partners set up this organisation, and one of us is a high-level quadriplegic. It all started when we did a project at the Royal College of Art designing a wheelchair for Bangladesh. We won an award, created the Trust and now have 25 people on the staff." Why design a wheelchair for Cambodia? "Well, with so many landmine victims in Cambodia, there was a crying need for wheelchairs there."

Why make it out of wood? Simon explains: "Because there was a shortage of tubular steel in Cambodia and a poor electricity supply. We produce our design, set up a partnership with a local manufacturer and withdraw. The Mekong uses abundant local hardwood braced with steel wire. It's easy to build and costs around £50, which is pretty cheap. Most are sold to NGOs (non-governmental organisation) such as the Red Cross."

Why does it have three wheels? "Well it might be madness for a car on a fast road, but for a wheelchair crossing rough terrain, it's ideal. The wide-profile path-finding front wheel makes it much easier to negotiate the rough tracks of rural Cambodia. And stability comes through what we call 'the milking stool' principle."

"We believe mobility improves people's quality of life, and the Cambodians are pretty mobile people. The landmine victims are in and out of their chairs all the time, the double leg amputees getting about by walking on their hands and swinging their bodies between their arms. You won't catch many Westerners doing that. The Cambodians use wooden blocks to keep their hands out of the dirt, so we've made special provision for storing those on the Mekong."

The Mekong Wheelchair has passed British Standard strength tests, and metal versions of Motivation designs are being made for Sri Lanka, Afghanistan and parts of Africa as tubular steel and electricity are more readily available in those locations.

THE MEKONG MADE IT TO THE FINALS OF THE 1996 BBC DESIGN AWARDS

SITTING PRETTY

Sc
GLASGOW

WEARABLE CLOTHING
DESIGNED FOR SITTING

WEARABLE CLOTHING LIMTED

Why on earth can't people in wheelchairs wear the same clothes as the rest of us? For quite a few reasons actually. Would you expect a fire-fighter to wear a dinner jacket on his way to a blaze? An extreme case, maybe, but it makes the point that different clothes do different jobs.

If you are sitting while reading this, and you're wearing trousers, look down. Would you walk around like that, with the hem half way up your calf? And have you noticed, when you're sitting in your car, that money slowly vibrates out of your trouser pocket and falls down that awkward crack in the back of the seat? Why? Because trousers aren't designed for people sitting down. They're designed to be worn standing up. That realisation became the germ of Patricia Watson's idea.

"I came across this problem when a friend of mine said that his wheelchair-bound wife just couldn't get any decent clothes," recalls Patricia. "I checked it out. Unbelievably the clothing industry didn't cater for the hundreds of thousands of people who can't stand up.

So I started Wearable Clothing. We don't use buttons, we use zips, studs and Velcro. We don't have pockets that drain their contents into the seat. We make clothes designed for the job, and that job is clothing people sitting down. So our clothes are designed for sitting!"

"Self-respect is especially important to people who are disabled," continues Patricia. "And stylish, fashionable clothing made to fit properly is important. Imagine if all your clothes distorted when you stood up! You'd be down to the shops immediately, insisting on a refund."

The Wearable Clothing collection is ever growing, and orders increase with each new catalogue. They will even make-to-measure, and keep customers' information on file for future purchases of every type of garment, from waterproofs to easy-access thermal underwear. The clothes are designed to be easy to put on and take off in a chair, to be comfortable and hard-wearing, and, perhaps most important of all, to look good and help the wearer to feel good.

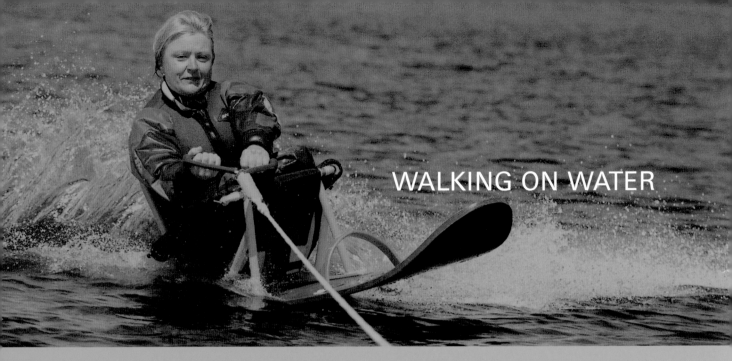

WALKING ON WATER

NW

CUMBRIA

MAX SEAT
SAFE SEAT FOR WATER-SKIING

DOMINIC BURGER, SEDBERGH SCHOOL

The flash of water inches beneath your body as you rip over the waves on a water-ski would test anyone's nerve. But the thrills and spills of speed-based sports offer an adrenaline rush which is rarely available to disabled people. Now, schoolboy Dominic Burger has opened up the sport to a far greater range of disabled participants.

"It came to A-levels and I decided to take Design instead of Art," recalls Dominic. "Then came the major project, and I was at a loss. I thought it would be nice to design something for disabled people, so I arranged to see Robin Nichols, honorary secretary of the British Disabled Water-ski Association. He told me there was a niche in the market for a seat for the beginner's ski because the existing model was a bit severe and wasn't adaptable for size."

"So I set to work to create a comfortable chair which would hold people securely on the board," Dominic explains. "I introduced a bucket-seat design with adjustable hip supports to accommodate all sizes and to stop any wobbling. I also included a padded back support to prevent skiers with limited upper body

strength from falling backward when the rope goes slack. I consulted teachers on various aspects of the seat's design and did all the welding and construction work for the prototype myself. The school has raised the money to build the first six seats which will be distributed among the UK's disabled water-ski centres."

The Max Seat has been well-received by disabled water-skiers who have been lucky enough to try it. Robin Nichols: "There was a particular problem with existing skis accommodating either wide or narrow hips. Dominic's design dealt with that very neatly. The resulting board is popular both with learners and their instructors. A sport like water-skiing is very important for disabled people. It can change mental outlook, give confidence and bring hope through what is a tremendously exciting experience."

Now Dominic's mission is to take the product further. "We've invested in a computer and are setting up a web page. The plan is to leaflet various disabled exhibitions around the UK and use the internet to locate and contact overseas interest."

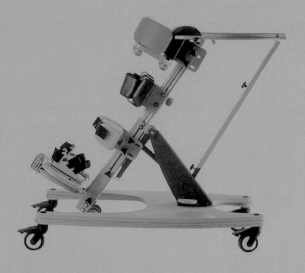

FRAMES FOR GAMES

NI

BELFAST

WOOSH STANDER
EASY-STANDER FOR DISABLED CHILDREN

JAMES LECKEY DESIGN LIMITED

A disabled child has more to cope with than we could imagine. Apart from the disability itself, there's the reaction of peers to both the disability and the medical equipment that some children may have to use.

Designer James Leckey is keenly aware of this fact. "To date, most equipment for disabled children has been grey, angular and dour," he explains. "It actually works to emphasise the stigma of disability. So we decided to try and do something a little more friendly in our design work and had such a positive response that we have put more and more energy into creating child-friendly designs."

"The Woosh series grew from some cartoon-like sketches," says James. "The curves on the side of the Woosh range have a feel of 'Vroom! Woosh!' – a sense of speed and movement – a valuable sensation for a disabled child. I went to visit a child at home and was greeted by his mother. She showed me into the living room where a Woosh Stander was occupied not by her child but by his friends, who all wanted to have a play on it. She was beaming with happiness because it was such a contrast to the equipment her son had used before."

The Woosh Stander, which aims to improve muscle development and posture for disabled children, takes its styling from an earlier product, the Woosh Chair. It looks both friendly and fun, which is an achievement for a piece of equipment that, unlike the chair, has no equivalent in everyday life. James explains: "The Woosh styling was difficult to translate from the chair, but we've had a very positive reaction to the Stander's appearance. And to help people relate to it better, we've also made it look a bit like a piece of gym equipment."

"We supply products to children with moderate to severe disabilities," continues James. "The standers that were available before simply didn't fulfil their needs. We've dramatically improved the range of anatomical support – adjustments are speedily made with hand knobs."

"It's easy to move a child into a standing position from their wheelchair or mat using the Stander because the frame can be quickly tilted from a horizontal to a vertical position. It's robustly put together and helps the child feel secure. Yet it is also configured to allow carers to get close to the child because the structure doesn't get in the way."

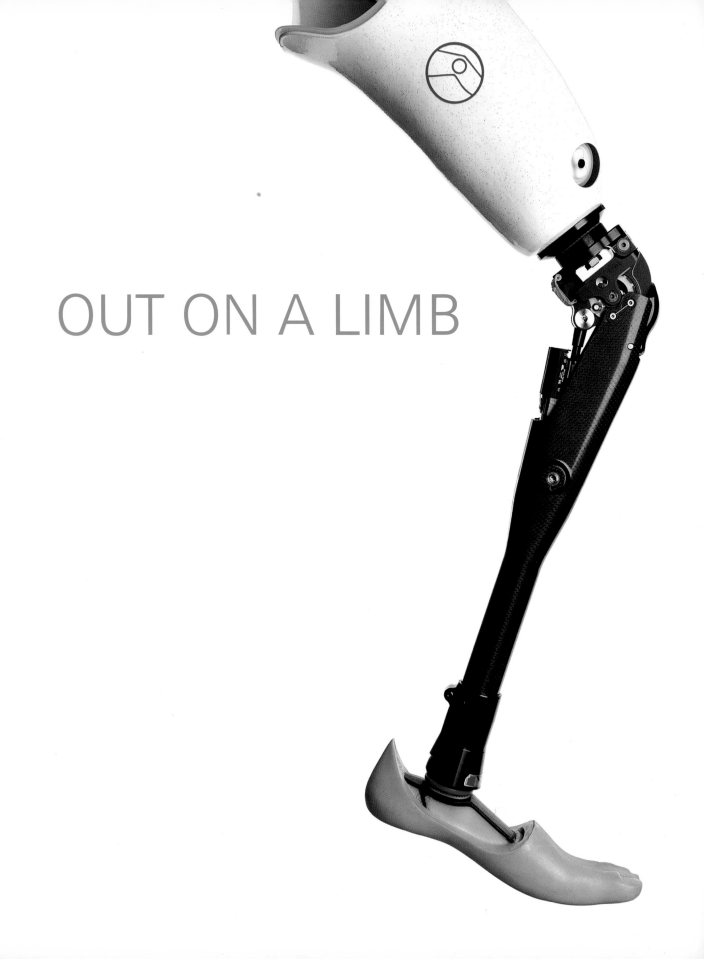

OUT ON A LIMB

SE

IP+
PROSTHESIS WITH CHIPS

BASINGSTOKE, HAMPSHIRE CHAS A BLATCHFORD & SONS LIMITED

The first thing you may notice about people with artificial limbs is the unusual way in which they walk. This is because the prosthesis doesn't adjust naturally when an amputee speeds up or slows down, so the gait can often become uncomfortable and awkward. But Blatchford solved this problem by developing the world's first commercially available intelligent artificial limb.

The Intelligent Prosthesis Plus (IP+) contains a computer chip which automatically modifies the swing of the knee to create a natural gait that matches the user's original walking pattern. This means that amputees can walk at different speeds in comfort and with minimum effort; they can walk further and move faster.

Andy Sykes, Blatchford's electronic design engineer: "IP+ is specifically designed for above-the-knee and through-the-hip amputees. What we do is work out the amputee's entire range of walking speeds and then programme the IP+ with those characteristics. This development was a massive improvement on conventional artificial limbs which were usually set at only one speed. This meant that if you tried to go faster you got too much heel and knee rise. Any slower and you began a sort of goose-step. With this prosthesis some amputees do take a much greater part in outdoor activities, games and sports, because they can change speed without thinking about it. It's like an automatic gearbox."

Blatchford is working on further generations of products controlled by microprocessors to provide even more advanced control than the IP+. " In the future limbs will automatically adjust for stairs, slopes, standing and stumbling, thus maximising the amputee's ability to control the limb," explains Andy. "The end result being that they'll be able to walk easily, naturally and safely."

PULLING POWER

Lon

THE SHADOW AIR MUSCLE
COMPRESSED-AIR MUSCLE

LONDON THE SHADOW ROBOT COMPANY LIMITED

Ever since robots first clanked and pistoned their way across laboratory floors, scientists have battled with one simple problem – how to imitate a human muscle. Pneumatic and hydraulic cylinders tend to be bulky and awkward and show a distinct reluctance to wrap themselves around skeletal structure in the way natural muscle does.

Richard Greenhill was mentally tackling this problem a few years ago, thinking what he could do to make artificial muslces using air bladders. "When I'm trying to find a solution, I have this habit of wandering into shops, looking for inspiration, hoping that something will spark an idea. That day I went into a John Lewis department store. They were having a sale and I saw a pile of children's bridesmaids' net gloves that had been heavily reduced. I suddenly saw in the fingers of these gloves the solution to the robot muscle problem."

"It was my Eureka moment. I thought that if I covered a bladder in a tube or sheath of this netting, attach one end to the skeleton's upper arm, the other end to the forearm, then inflate the bladder with compressed air, the bladder will expand the net, shorten its length and pull up the forearm! So I picked up the gloves and went in some trepidation to the counter, worried that people would think I was a bit for odd buying 14 pairs of children's net gloves."

Richard had realised that the expanded net would produce a lengthwise contraction of the bladder (just like a human muscle), because the mesh, when expanded widthways, automatically gets shorter in the opposite plane. It's easy to demonstrate. Take a length of netting and lay it on the table. Pull the top and bottom. The mesh opens up between your hands, and its length reduces.

"Robotics is the major application," says Richard. "We've received a DTI Smart Award to help us work on developing a robotic human hand. You just can't do this with anything other than an Air Muscle. There are too many movements. But it will be a challenge to achieve the strength of a human hand in all planes – people can hang from cliffs by their fingertips! However, the Air Muscle is far more likely to achieve this than any other system."

Richard and his colleagues at the Shadow Robot Company are also working on artificial hands for handling hazardous substances like nuclear materials. "Current versions lack dexterity," he says. Animatronics (the building of robotic puppets) is another possible application.

"We're also working on 'virtual' hands which might eventually be used, for instance, by MS sufferers. The idea is that they would put their weakened hand into a 'data glove' on their wheelchair, and that will control an Air Muscle hand mounted on the armrest."

AND THE WORD
WAS MADE SENSE

SE

SLOUGH, BERKSHIRE

VISUAL TRACKING MAGNIFIER
READING LENS FOR DYSLEXIA

COMBINED OPTICAL INDUSTRIES LIMITED

A cure for dyslexia? It's a dream that many people would like to come true. And perhaps optician and dyslexia author Ian Jordan is coming close.

The Visual Tracking Magnifier (VTM) looks like a simple piece of equipment, but the maths and the theory behind it are complex.

Ian Jordan: "When you read, your eye focuses on one word group and then flits forward to focus on another group – this is called Visual Saccade. In the process your brain is bombarded with information about the contrast between the black letters, the white page and the spaces between the letters and the words. For many dyslexia sufferers, all this extra information over-stimulates the brain and causes the words and letters to become muddled up in their heads."

"What the VTM does is suppress the background information, allowing the reader to concentrate on a single, well-lit section of text," explains Ian. "The reading band in the VTM is etched with tiny black dots which reduce pattern glare – the stroboscopic effect of lettering which can cause further confusion for some people."

The VTM is a clear plastic optical dome containing a horizontal magnifying strip. The user places the VTM over the text and looks through the strip window at a small section of text. The reader slides the Magnifier along, concentrating on short sections of text at a time. They can also rotate it through ninety degrees to look at individual letters and break down words phonetically.

"It's ideal for children who are learning to read, since you move the VTM along the page at your own pace," says Ian. "For people who have learnt to read or cope with dyslexia, it's probably too slow. But it is an excellent tool for those who have given up on reading. And when you get older, it comes into its own again, for it can help people with cataracts or macular degeneration to focus." (Macular degeneration happens when the blood supply to the centre of the eye is restricted.)

People who suffer from optic atrophy and tunnel vision are also benefiting from the device, and response to this new product has been very enthusiastic.

om, sap, etc., from. [OE *milc*]

and water *when postposi-*
d.

t which milk drinks and light
(in Australia) a shop selling, in
sions and other items.

ate that has been made with

notor vehicle used to deliver

d thrombosis of the femoral
aracterized by painful sw...

irl or woman who mil...
-men. a man who c...

ension of magnes...
cid and laxative.

it. a pudding ma...
esp. rice.

oute along which
regular series of v...
s from industry to u...
nf. a routine and u...
s safe and regular ro...
rink made of milk, flav...
hisked or beaten toget...
eeble or ineffectual man...

for **lactose.**

st teeth to erupt; a deciduous
th.

of several plants having small
They were formerly believed
n nursing women.

milkiest. **1.** resembling milk,
2. of or containing milk. **3.**
lkily *adv.* —**'milkiness** *n.*

use band of light stretching
sists of millions of faint stars,
t of the Galaxy. [C14: transla-

d with machinery for process-

book covers. [C18. from *milled board*]

milldam ('mɪl,dæm) *n.* a dam built in a stream to rais...
water level sufficiently for it to turn a millwheel.

millefeuille *French.* (milfœj) *n. Brit.* a small iced...
made of puff pastry filled with jam and cream. [lit.:...
sand leaves]

millefleurs ('miːl,flɜː) *n.* (*functioning as sing.*) a des...
stylized floral patterns, used in textiles, paperweights...
[F: thousand flowers]

millenarian (,mɪlɪ'nɛərɪən) *adj.* **1.** of or relating to a...
thousand years. **2.** of or relating t...
narianism. ~*n.* **3.** an adherent o...

reign on earth: bas...
a future period of ide...
millenary (mɪ'lɛnərɪ)...
of one thousand. **2.** and...
n. **3.** another word...
millēnārius containing...
millennium (mɪ'lɛnɪəm...
the. *Christianity.* th...
Christ's awaited reign...
one thousand years. **3.**...
in the distant futu...
re year...]

(...nɪzəm) *n.* **1.** *Christia...*
ium during which Chris...
ation 20:1-5. **2.** any bel...
d happiness.

es. **1.** a sum or aggr...
for a **millennium.** -
arian. [C16: fro...
d, from L *mille* thou...

niums or -nia (-n...
of a thousand yea...
n. **2.** a period or cy...
peace and happiness...
n NL, from L *mille* thou...
adj. —**mil'lennialist** *n*...

illeped *n.* variants of...

) *n.* any of a genus of tropical col...
zoans, having a calcareous skeleton.
from NL, from L *mille* thousand + *porus* hole]

miller ('mɪlə) *n.* **1.** a person who keeps, operates, or v...
in a mill, esp. a corn mill. **2.** another name for m...
machine. 3. a person who operates a milling machin...

Miller ('mɪlə) *n.* **1. Arthur.** born 1915, U.S. dramatis...
plays include *Death of a Salesman* (1949), *The Cr...*
(1953), *A View from the Bridge* (1955), and *The Ride...*
Mt Morgan (1991). **2. Glenn.** 1904–44, U.S. band le...
His compositions include "Moonlight Serenade". He...
when his aeroplane disappeared on a flight between...
land and France. **3. Henry.** 1891–1980, U.S. novelis...
thor of *Tropic of Cancer* (1934) and *Tropic of Capr...*
(1938). **4. Jonathan (Wolfe).** born 1934, British d...

FEEL THE COLOUR

SE

**BRIGHTON,
EAST SUSSEX**

TACTILE COLOUR
CODED COLOUR SYSTEM

TACTILE COLOUR COMMUNICATION

Lois Lawrie was born with a gift for the visual. She became a graphic artist and a printer, and her love affair with colour, image and text was a long and rewarding one. Until, at the age of 30, she went blind.

Now, aged 45, she says, "I'm advantageously blind. I can remember what it was like to see and can recall images. So many blind people don't have that. It's a big advantage." In her determination to share a part of that advantage with other blind people, she conceived of Tactile Colour.

"It started for me as an art medium. I wanted to be able to make images again. I thought, there must be a way to represent colour by touch. We've now come up with representations for 12 different colours. Each has

an individual texture which we can either directly print on to paper, or sell as adhesive vinyl which can be cut to shape."

"We follow the spectrum," says business partner Steve Purkis. "Red has a smooth, rubbery texture, Orange is a bit lumpier, Yellow, less rubbery and more bobbly, Green is gritty, and so on, towards fluffier textures, and ridges for Brown. It takes on average around 20 minutes to learn the differences."

Tactile Colour has the potential to open up a whole new world to people with visual impairments. It becomes easier to trace the multi-coloured lines of a London Underground map, for instance, and means that maps of all types can carry more information for the blind. Plus, there are a whole host of educational applications, enabling visually impaired children to enjoy more games, both with each other and with their sighted peers. "I was playing a version of Snakes and Ladders with a child recently," recalls Lois. "She had cut the 'snakes' out of one texture of the tactile vinyl and the 'ladders' out of another. It really was so simple and such good fun."

With the arrival of the new millennium business is growing for Tactile Colour. "The UK's Disability Discrimination Act requires all information to be made accessible to disabled people," says Lois. "So a map in a public place, for example, won't meet the requirements of the law unless it's tactile. We are now trying to develop vandal-proof ways of printing on wood and other surfaces."

SOUNDCHECK

E

ECHOCHECK
BABY'S FIRST HEARING TEST

HATFIELD, HERTFORDSHIRE

OTODYNAMICS LIMITED

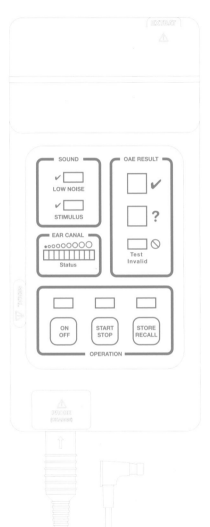

How do you know if your baby has hearing problems? It is remarkably difficult to tell, which is why the average age of detection of hearing loss in children is two years old. Those are two vital years during which language acquisition and familial bonding may be significantly and permanently impaired.

But now Otodynamics has developed the Echocheck, a quick and easy way to tell within hours of birth whether a baby has any hearing problems. This means surgeons can take early action, or doctors can fit hearing aids within the first few months of life. And that makes for less frustration and a closer bond for both baby and family.

Sharmila Gardner is part of the team that developed the Echocheck. She is an OAE application development scientist at Otodynamics. OAE stands for otoacoustic emission and is at the heart of this detection system.

Sharmila Gardner: "The Echocheck unit sends a sound into the inner ear. If everything is OK the hair cells there will respond with an otoacoustic emission, sending the sound back like an echo. If the Echocheck picks up no response it means there could be a problem in the inner ear, and the unit alerts a doctor to investigate further."

The appeal of the Echocheck lies in its low price and ease of use. "Because it's a screening device and not diagnostic, it's inexpensive and you don't need much training to use it. If everything is OK, you'll see a green light, and if it isn't OK, you won't. It's that simple, really." The battery-powered, self-contained, pocket-sized instrument is designed for use in maternity units, clinics and at home by health professionals.

WINNER OF THE 1998 QUEEN'S AWARD FOR TECHNOLOGY

SUCK IT AND SEE

Lon

LONDON CANNON AVENT GROUP PLC

AVENT ISIS BREAST PUMP
IMITATES NATURE

Breast is best for baby. It's pretty obvious, isn't it? Strangely, it's become "obvious" only in the last 10 years or so. Before that, our faith in science was such that many mothers gave formula milk to their babies in preference to Mother Nature's recipe. Now the Department of Health regularly issues leaflets saying that babies fed on breast milk have higher IQs, better immunity and all-round better health than formula-fed babies. They also say that breast-feeding mothers will lose the fat stored during pregnancy more quickly and be less likely to contract breast cancer and ovarian cancer. They also say that formula-fed babies are five times more likely to go to hospital with diarrhoea, twice as likely to be hospitalised through chest infections and are more likely to die in cot death or be overweight.

So, if it's also true – as the NHS and others claim – that at least 99 women in 100 can breast feed, why don't more do it and for longer? The answer is, inconvenience. Not that it's easy to sterilise bottles and prepare formula. It's far easier, in fact, to breast feed. But breast feeding can't be shared. Formula preparation can, however, so that partners and other caretakers can alleviate the load.

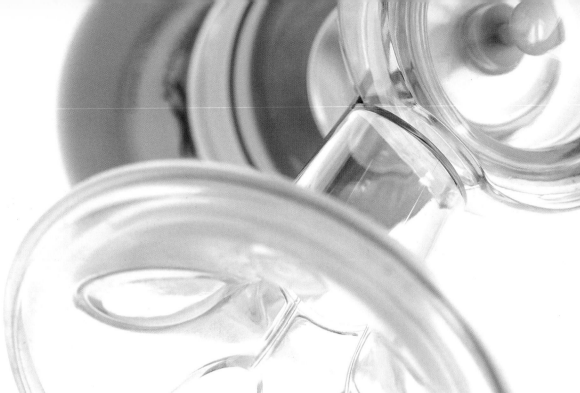

Well, now it's possible to share the load and give a baby breast milk, quickly and easily. There have been a variety of breast-pumps on the market for a while, but they have disadvantages. The electric ones are expensive and noisy, and the manual ones are not very efficient. Both these types work by suction, which is fine, except that babies don't feed by sucking the milk, they feed by stimulating the mother's breast with their lips, gums and tongue before drawing the milk into their mouths with a sucking and dragging motion.

Graham Tulett, design manager at Cannon Avent: "We realised that there had to be a better way of making a manual breast pump. With our design consultancy Isis, we began to think of ways to imitate nature. In the end we came up with a transparent cone with a soft, see-through silicone lining that has petal shapes all around it. This goes over the breast. As you press on the pump handle, the petals massage the aureole and encourage the 'let-down' effect, and milk begins to flow. We've kept the whole design completely transparent, so the mother can see exactly what's happening. And we've come up with a far

better pumping mechanism, using a silicone diaphragm rather than the more clumsy piston. It means you get more milk, more quickly, and with considerably less stress, frustration and effort." And that means that it can be stored in the fridge for Mummy's little helps to take over.

"The new pump has been incredibly successful," explains Graham. "Recent hospital trials have shown that mothers prefer them to electric pumps. In fact we've recently shelved plans to produce a new model of electric pump precisely because the Isis has done so well." Isis? You named it after your design consultancy? "Well, not exactly. We have an excellent relationship with them, and the Isis was the result of a great team effort. But, in fact, the name was suggested by someone in the company, because Isis is the Egyptian goddess of fertility and is often represented with a baby at her breast."

Lon

BODY POSITIVE
SUPPORT & FACILITIES FOR
HIV POSITIVE PEOPLE

BODY POSITIVE

The first deaths from AIDS in the UK were recorded in 1983. These, along with alarming reports of the outbreak from the USA, caused great anxiety, particularly among gay communities. Government and health agencies were unsure of how to react to this poorly understood virus. Research and safe sex campaigns were instigated, but there were few resources for people already diagnosed as HIV positive. So, the increasing number of HIV positive people began to turn to each other for support. As a result Body Positive was formed.

Then, in 1996 there was a medical breakthrough. New treatments (such as Saquinavir, see page 50), used in combination with other drugs, were keeping people alive, and many experienced a return to good health.

It soon became obvious that the needs of people with HIV were changing. People wanted information about the confusing number of treatment options. They needed help coping with the serious physical side effects, and those who were well enough wanted to get back to work.

Paul Abbott, head of marketing at Body Positive: "The number of people becoming infected with HIV each year has remained pretty constant. However, the amount of people living with the virus is increasing because, thankfully, people aren't dying in the same numbers. There are many people alive today who two years ago really didn't think they would be. Now they're contemplating the

future, which is why we offer a work training programme. Some have totally missed out on the IT revolution, and so our course enables people to gain an NVQ in Information Technology, Business Administration and Customer Care Skills. We also arrange work experience placements so that people can find out if they're ready to cope with a new working life."

Body Positive's headquarters in the heart of London is a hive of activity, because it offers state-of-the-art facilities. Paul: "We have perhaps the best library resource on HIV treatments in the UK. And there's loads of information on the net, so we've got six PCs on-line. It's not exactly an internet café, but you can make coffee and it's free."

Another important rehabilitation tool is the Body Positive gym. "People are quite often disabled by HIV and debilitated by the drugs' side effects. Exercise can also suppress the immune system, so it's important that individual programmes are carefully worked out and monitored," says Paul. "Body image and going to a gym is a big issue these days, so it's hard for some HIV positive people to feel comfortable in a public gym."

Body Positive is a unique mechanism for administering both practical and emotional support to people in need, which is why it has gained Millennium Product status. It's also offering a level of care and commitment that's obviously well appreciated.

SAQUINAVIR
WORLD'S FIRST HIV PROTESE INHIBITOR

WELWYN GARDEN CITY,
HERTFORDSHIRE

ROCHE PRODUCTS LIMITED

At the dawn of the new millennium, the war against AIDS seems almost won. The death toll has been dramatically reduced, and new drugs promise to neutralise the effects of this vicious virus. Success has been due, in no small part, to the pioneering development of the British drug Saquinavir, one of the first "designer molecules".

Dr David Clough, director of research at Roche Products Limited: "In the late 1980s, research revealed the structure of the HIV virus. It became clear how the virus used an enzyme called HIV Protease as a vital agent in its reproductive process. We quickly realised that if we could attack the Protease and inhibit its activity, we could effectively stop the HIV virus from reproducing. We could, in short, stop the disease spreading throughout a patient's body allowing them to live longer – perhaps much longer."

Head of antiviral biology, Dr Noel Roberts: "When an HIV-infected human cell produces new virus particles they can't turn into mature infectious viruses unless the HIV Protease enzyme cuts up long protein molecules to make the right-sized 'building blocks'. The trouble was, humans use similar proteases for cutting up the protein in their food and for controlling blood pressure. So inhibiting proteases was potentially dangerous."

"We had to design an inhibitor molecule that would physically lock into the HIV Protease and stop it from cutting proteins," he continues. "The molecule would have to fit the HIV Protease like a jigsaw piece, or like a guard over a knife. But we also had to make sure that the inhibitor didn't fit human proteases as well. Then we discovered that the HIV Protease cut proteins in a specific place. So we used this unique site as the basis for the chemical structure of the inhibitor."

Speed was an important factor in the team's success. Dr Roberts was assigned the task of establishing whether the experimental molecules were successfully inhibiting HIV Protease. "We were trying to make the world's first rationally designed antiviral agent that included the creation of a chemical molecule that physically fitted its target. We had to know quickly whether our various 'shapes' were working or not." Dr Roberts' Eureka moment came when after nine months he generated a test that could tell within six hours whether a prototype molecule was locking with the HIV Protease. "It gave us an edge that the other drugs companies didn't have," explains Dr Clough.

About 250 chemical compounds were created in order to identify the best inhibitor. This work was led by Dr Joe Martin and it was Dr Sally Redshaw who eventually produced the optimised compound Saquinavir, which emerged from Roche's research and development programme in record time. It was the first time an antiviral agent which had been specifically designed to block a precise process in the lifecycle of a virus had come to market .

Clinical studies showed a fifty per cent reduction in death rates and disease progression compared to existing therapies. Invirase, the first commercial formulation of Saquinavir, was launched in the USA in 1995, and continues to be used. But Roche has since produced Fortovase, a more potent form which delivers higher levels of Saquinavir.

The work on proteases also has implications outside AIDS therapy and could one day benefit victims of hepatitis C.

THE DRUG THAT PHYSICALLY FITS

SCIENCE CAN BE FUN

SE

SANDWICH, KENT

VIAGRA™
MEDICATION FOR MEN

PFIZER LIMITED

While conducting trials on a new drug aimed at combatting angina, scientists at Pfizer's Central Research Laboratories were about to give up. The new drug didn't seem to be working any better than existing treatments. But then they discovered that "sildenafil" had another potential use. Apparently that sort of crossover happens quite a lot in the pharmaceutical industry. But their discovery, that it could treat male impotence, was a first. Six years later, Viagra™ hit the headlines.

Why? So what if men can't get erections? Pfizer's Andy Burrows: "Male impotence has, until recently, been considered as just one of those things that's part of the ageing process. Only over the last few years has it been realised that sexual health is important to the mental well-being of men and women, and that being unable to perform sexually often leads to a dramatic drop in self-esteem. High self-esteem helps to prevent depression. Low self-esteem can be a significant contributory factor in serious cases of depression. So Viagra is not just a 'sex drug'. It is important to many people for both their mental and their sexual health."

Surprisingly, sexual health has only recently begun to be taken seriously. A few years back, British neuroscientist Giles Brindley announced at a scientific convention that he'd just injected himself with Phenoxybenzamine, and undid his trousers to reveal the result. Such injections quickly became the main means of treating impotence.

But injections can be inconvenient and sometimes painful. Another method, using a vacuum tube and a pump, was also rather cumbersome and not completely effective.

Erections are caused by spongy tissue in the penis becoming engorged with blood. Impotence, it is now realised, is often caused by the penis's inability to fill with blood. Viagra works by enhancing the blood supply to the genitals. Until very recently, impotence problems were mainly thought to have psychological roots. It was then realised that the penis was as susceptible to arterial hardening and blockage as the rest of the vascular system. So, Viagra addresses the problem of poor blood supply.

Viagra has also had an unexpected and more fundamental effect. "Prior to Viagra, there had been comparatively little serious research into the way sexual organs worked," continues Andy. "Viagra has created a revolution in medicine, an entirely new field, making sexual health a major scientific pursuit. It is now highly likely that there will be major advances in sexual medicine because Viagra has amply demonstrated the existence of a largely ignored medical need."

How large? Viagra is one of the most successful new medicines in history. Three-hundred thousand prescriptions were written within six weeks of its American launch and in 1998 it grossed £500 million for Pfizer. To say it's captured the public's attention would be an understatement.

E

DUREX AVANTI
THE POLYURETHANE CONDOM, MADE FOR COMFORT

BROXBOURNE,
HERTFORDSHIRE

LRC PRODUCTS LIMITED

Long has the condom languished in the shadow of the contraceptive pill. Some may say not long enough. For what is less sexy than a smelly bit of latex strangling your private parts? But post-AIDS the world has changed and the condom is back with a vengeance, newly billed as the trusty suit of armour, protecting against a range of devastating sexually-transmitted infections. So, by popular demand, the race for a more comfortable condom is on.

Suren Solanki, research manager for Durex family planning projects, and Adrian Lyszkowsky, Durex's research manager for new materials, have long been engaged in the hunt for a sexier material than latex. "There were two main negatives we were trying to address," says Adrian, "the unpleasant smell sometimes associated with latex and the lack of sensitivity which gave rise to all sorts of jokes such as making love wearing a condom is like shagging with your raincoat on."

"So we conducted a review of all the different polymers available," continues Adrian. "We figured out that if we used synthetic material we could eliminate the smell and get something that was as strong but considerably thinner.

The most likely candidate was polyurethane, which may be made into so many different forms that there was more scope for success. Unfortunately, nothing suitable was available commercially, so we commissioned a manufacturer to test the boundaries of polyurethane material science and make what we wanted. They produced something even better than we'd dare hope for."

Suren Solanki: "The material we use in Durex Avanti is as strong as latex but around forty per cent thinner. It doesn't smell and has the added bonus of being completely clear – it's almost invisible. The sensation is much closer to that experienced during unprotected sex. And there's another plus – people who are allergic to natural rubber latex can use this product."

Imitation is the highest form of flattery but two similar products haven't performed as well. One from Japan was withdrawn after evidence of problems, and the other, from Holland, hasn't proved popular. So, the Durex Avanti is here and it's making it's presence felt. It's lean, it's clean, and at the turn of the century, say its aficionados, it's the king of condoms.

TOUCHY FEELY

IF THE GLOVE FITS ------------------------------

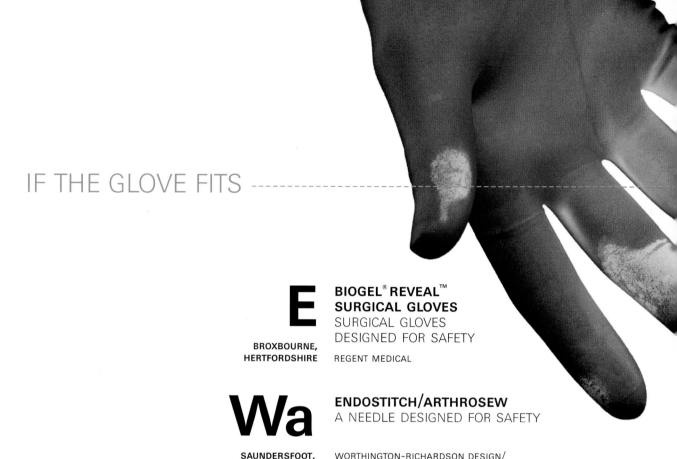

E

BROXBOURNE,
HERTFORDSHIRE

**BIOGEL® REVEAL™
SURGICAL GLOVES**
SURGICAL GLOVES
DESIGNED FOR SAFETY

REGENT MEDICAL

Wa

SAUNDERSFOOT,
PEMBROKESHIRE

ENDOSTITCH/ARTHROSEW
A NEEDLE DESIGNED FOR SAFETY

WORTHINGTON–RICHARDSON DESIGN/
UNITED STATES SURGICAL CORPORATION, TYCO GROUP

You're a surgeon, working fast to sew up a car crash victim who has an infectious blood disease. Unwittingly you prick your fingertip with the sewing needle. You don't even know that you've done it because your gloved fingers are covered in blood and in the rush you felt nothing. Then, to your horror, your fingertip begins to turn green.

A Hammer Horror story? A rejected scene from *Alien*? No, this is reality. But it's not all bad news – for the spreading green stain is a warning sign that says, hey, these gloves have been compromised. Seek immediate treatment!

Former nurse Pam Richardson and her husband Phil, a retired university lecturer, live in a remote part of Wales. These days they're known as Worthington-Richardson Designs and are professional inventors, dreaming up innovations. When they have a usable product, they'll offer licensing deals to various manufactures.

The couple invented the gloves after playing around with some balloons one day. Phil: "We were looking at how to generate colour change as a warning or indicator. I was

fiddling about with some balloons. I blew one up and noticed the moisture on the inside. Then I decided to put a red balloon inside a white one. When I blew it up I noticed the moisture trapped between the two balloons caused a red patch to appear. It was a clear colour change caused by liquid and air invasion."

Pam: "We applied the principle to surgical gloves and created these double gloves. First you put on a green glove, and then you pull a translucent one over the top. If the gloves are punctured, capillary action draws moisture between the two layers and so highlights the green glove beneath. The spreading green stain alerts you to the possibility of cross-contamination."

Worthington-Richardson Designs have also patented the system as a mail security device. Should a package be tampered with and air let in, the packaging will immediately change colour.

OK, so here's another one. You're a surgeon working fast to sew up an internal wound during keyhole surgery.

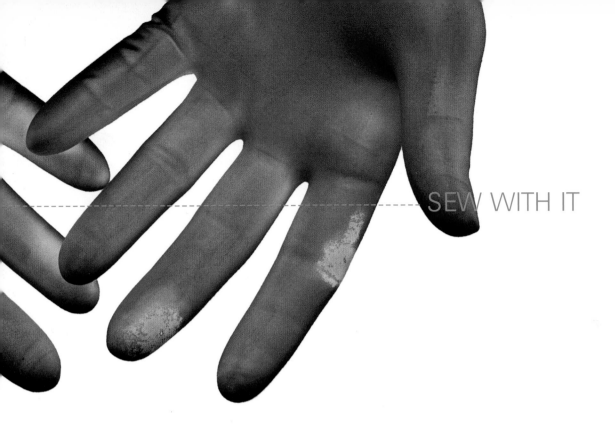

You're fiddling about – inside – with a pair of tweezers trying to pull the needle through when, ah, you drop the needle and it falls into the wound.

Pam: "We were aware that it was very difficult to sew up internal incisions during keyhole surgery. We thought the problem might be solved with lasers and we contacted the United States Surgical Corporation with a proposal. Their chief executive flew over on Concorde, and then took a private plane up to our place in Wales. After some discussion we agreed laser surgery was going to be too complicated, too high-tech. So we began to look for a mechanical solution. A few months later we had the answer after persuading our local blacksmith to make a prototype to our design. We were flown over to the USA, sold them the licence and it's been very successful." As one American surgeon declared: "If that instrument isn't on my tray, I'm not coming in."

So, what is this magic tool? Imagine a sewing needle with two sharp ends. In the middle of the needle is the eye, through which the thread is drawn. Now imagine a device used for picking up small screws that have fallen down the back of a workbench. It's a long tube with jaws at one end that are operated remotely by scissor-handles at the other end. That's the new Endostich/ Arthrosew.

The tube terminates in two needle holders like the jaws of a crocodile clip, set opposite each other. The needle sits in a clip in one of the jaws. You open up the jaw so it bridges the wound that is to be sewed, with the needle poised ready for penetration. You squeeze the scissor handles and the needle passes through the flesh, drawing the thread with it. The needle point then enters the opposite jaw. And clicks into place. As it does so, it frees itself from the first jaw. Now the needle, gripped in the opposite jaw, is poised for the return journey.

This device for surgical stitching is far easier to master than the conventional method, and it's speedier, better at penetrating tough tissue and safer. In short, it's simple, brilliant, and like the Biogel Reveal, it's a world's first.

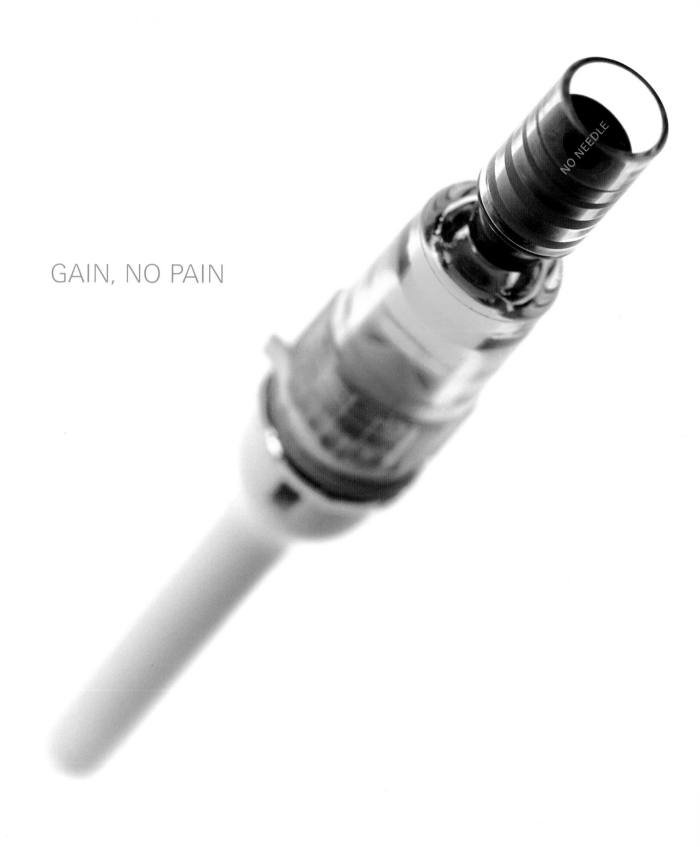

GAIN, NO PAIN

NO NEEDLE

E INTRAJECT
A BREAKTHROUGH
NEEDLE-LESS INJECTOR

STRADBROOKE, SUFFOLK WESTON MEDICAL LIMITED

Most people hate needles: they hurt, and they're dangerous. Some sources site needle-stick accidents as the biggest cause of injury to health-care workers. Yet despite more than 60 years of development, which has spawned over 350 patents, needle-free devices are not widely available because most are expensive and difficult to use.

Now Weston Medical has developed the world's first pre-filled, disposable, low-cost, skill-free, needle-free device for administering liquid drugs. In less than five seconds, patients can self-inject medication, without a needle.

This disposable injection system is the first pre-filled device to be developed for use with liquid drugs; previous products were designed for powdered drugs. This means that many medications, including hormone injections and vaccinations, can be delivered more safely, with less stress and pain for the patient.

The idea was born on a Dutch pig farm. Terry Weston was commissioned to come up with a more efficient device for vaccinating pigs. Later, when chatting to his doctor, he mentioned the invention. The doctor said, "Pigs? Terry, you should be making these for humans."

By using pressurised gas to force the liquid through skin without piercing it, an Intraject injection takes just 30 milliseconds, and it feels as if someone has simply tapped you on the skin.

Khawar Mann, director of business development: "In less than two years we've struck four licensing deals with large drug manufacturers for treatments for diseases such as hepatitis C and thrombosis. Another big area is migraine treatment. Intraject is also being used in combating anaemia suffered by dialysis patients. But a promising and rewarding area is infertility treatment. Most people don't realise that you often have to undergo a month-long course of daily injections to tackle this problem. Intraject promises to take the pain out of that process."

Designed for sub-cutaneous injections, Intraject is only marginally more expensive than traditional syringes, so it could spell the end for queues of schoolchildren waiting in trepidation for the vaccination "jab".

Currently Intraject is pre-filled with a fixed dose of a supplied drug. Weston Medical is also working on new versions of Intraject which will allow it to be used with a wider variety of drug treatments.

Wa

LARVE
STERILE, LIVE GERM-BEATERS

**BRIDGEND,
MID-GLAMORGAN**

BIOSURGICAL RESEARCH UNIT (SMTL)

RETURN OF THE FLESH-EATERS

The idea of maggots crawling out of a wound is enough to make anyone reach for the sick bucket and, in the realm of cinema the image has been used to disturb many a horror film audience. So, it's somewhat alarming to learn that doctors are never happier than when they're dropping larvae from the hideous greenbottle fly (aka lucilia sericata) into an open wound.

Now calm yourself, because maggots are very good at cleaning dead and decaying tissue from wounds and are far more tissue-friendly than antiseptics and antibiotics. The trick has been to make the little critters sterile so they don't bring any new infections to old wounds.

Dr Steve Thomas heads up the Biosurgical Research Unit. "If you look at the average chicken egg, the outside looks pretty contaminated. But inside, it's more sterile than the best operating theatre. The same is true with greenbottle eggs. We sterilise the outside of the eggs, let them hatch into a sterile environment, and test for any breach of sterility." How do you sterilise something so small without killing it? "That's our little secret," replies Dr Thomas.

But won't these maggots turn into flies inside the wound? "No," says Dr Thomas. "We take them out of the wound after three days. A maggot doesn't even think about becoming a fly until after four days, and then it'll take another week to actually change." Ah, OK. "The dressing prevents the maggots finding their way to healthy skin, because then the patient will feel them." Right, so the patient doesn't normally feel them chomping away at the dead and decaying tissue? "Oh no, because the nerves are dead anyway." Gulp.

Despite our squeamishness, the maggots are a medical miracle. Unlike antiboitics, maggots not only kill bacteria but they also remove dead tissue which helps the wound to heal. Plus, there is an increasing problem with antibiotic-resistent bacteria, but the maggots can kill that off as well.

One surgical nurse said: "We are getting a ninety per cent success rate, from traumatic to long-standing wounds, with a three to six-day healing rate with the older wounds. It'a amazing, ten-year-old wounds can clear up in a few weeks, and we're saving limbs that might otherwise have been lost."

DRASTIC PLASTIC

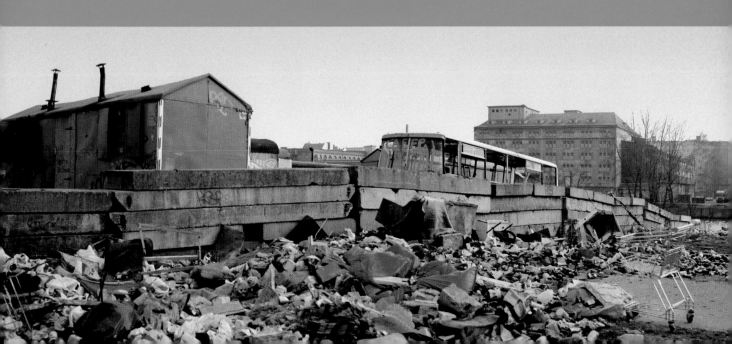

POLLUTION SOLUTION

E

TUFFY® SPI-TEK™ 100% DEGRADABLE POLYTHENE SACKS
PROGRAMMABLE DEGRADING PLASTIC

BOREHAMWOOD, HERTFORDSHIRE

SYMPHONY ENVIRONMENTAL LIMITED

An ocean of black plastic bin-liners. Inside, a range of domestic waste that isn't breaking down because it is protected by the bag itself. A rubbish dump that never fully degrades. Plastic that pollutes the landscape and chokes animals. These are serious problems in our throw-away society.

But now a British company has come up with a one hundred per cent degradable polythene film. Robert Bobroff, business development manager, Symphony Environmental: "Using our Tuffy® SPI-TEK™ technology, with EPI® and DCP™ additives, Symphony have created probably the first totally degradable polythene sack in the world."

"The material has all the dynamic properties of standard polythene, but will degrade completely over various timescales depending on its application, breaking down into minute quantities of CO_2 and water. There are a whole range of applications for short-term one hundred per cent degradable polythene bags, including refuse sacks, bin liners, compost bags, carrier bags and food-produce wrappers."

Numerous local councils, retailers and end-users are already purchasing these environmentally responsible products. The Fyffes Group are currently using several configurations of one hundred per cent degradable polythene bags, with a view to adopting them at all stages of banana production and distribution, including the bags used to protect banana bunches in tropical fields. A major bakery is carrying out trials and a number of supermarket chains are also interested.

Symphony Environmental is currently testing other applications for this one hundred per cent degradable polythene technology, including stretch film, clingfilm, tea bags, nappies and vending cups.

AN UNLIKELY RECIPE

MANCHESTER

GREENPEACE CARD
WORLD'S FIRST BIODEGRADABLE
CREDIT CARD

THE CO-OPERATIVE BANK

A credit card made of degradable material – big deal!
A few titchy credit cards are hardly likely to overflow the
landfill, are they? That's a reasonable reaction to the
news that the Co-operative Bank have created a self-
disposing credit card, isn't it?

"Not really," says Paul Monaghan, the bank's ecology
manager. "With information technology cutting down
on paper transactions, banks are becoming greener. At
the Co-op Bank we recycle a very large proportion of
our paper. The next big issue that needed attention was
cutting down on the tons of plastic we use to make
credit cards. And there's a more serious problem."

The serious problem comes in the form of dioxins,
which PVC gives off during manufacture and disposal.
"Dioxins are widely believed to cause cancer," says Paul.
"They are also thought by some scientists to cause
endocrinal disruption, which means they disturb the
hormone system. Already dioxins have contaminated
many aspects of our lives. Using less PVC is one way
of bringing that under control."

So how do you make a self-disposing, dioxin and
carcinogen-free credit card out of plastic? The answer
is, use fungus. "Introduce fungus to the sugar from
sugar beet and it ferments just like yeast ferments
beer," explains Paul. "Only, in this case, the sugar
doesn't turn to alcohol, it turns to carbohydrate, in the
form of little grains of plastic-like material."

Biopol, as it's called, is currently quite expensive at
around 10 times the cost of PVC. But it breaks down
into harmless natural substances – CO_2 and water. It's
currently used for a variety of products including
washing-up bottles and, now, credit cards.

"It took a lot of effort to get the Biopol to behave like a
credit card," says Paul. "We worked with NBS Cards for
two years trying to get the material to take the
magnetic strip and be tough enough for repeated
swiping. The only thing we couldn't do is meet the
safety requirement that, should it catch fire, flames
would disappear within seven seconds. But then a
smouldering PVC credit card giving off dioxins is more
dangerous than a burning one. They've now dropped
that requirement."

And there's another plus. When you use the Biopol card
the Co-op Bank automatically donates money to
Greenpeace. But isn't a degradable card a bit risky?
Could you look in your wallet one day only to find a few
drops of water where once your flexible friend had
been? It would lead to the ultimate embarrassing
shopping experience when you're just about to pay for
something but you find that your card has accidentally
recycled itself. "Impossible," laughs Paul. "Unless, of
course, your inside pocket is as hot and rank as a
compost heap."

EXPOSED!

SW

HAMPSHIRE

TRIBOPEN & POLYANA
IDENTIFYING PLASTICS
MEANS CHEAPER RECYCLING

SOUTHAMPTON INNOVATIONS LIMITED

"You made it, you recycle it." That's the message being shouted by new directives to manufacturers around the world. On a planet where finite raw materials are being rapidly consumed to make items that are ultimately dumped as detritus, the time has come for every major producer to take responsibility for their mess and waste. Suddenly, a toy manufacturer has to account for the packaging of the toy, and car manufacturers have to find ways to recycle their cars.

But how? Up to 30 different types of plastic are used in modern motor cars. How do you tell which is which? Not even the manufacturers are sure. Ford Motors were among the first to see the writing on the wall. They approached Peter Mucci, head of the prototype group at Southampton University's Innovation Company to commission some help. And that's how Tribopen and PolyAna were born.

Peter Mucci: "There's a one-acre field up in the Midlands which is 20-feet-deep in plastic car bumpers. The owner's sitting on something of a gold mine. Except he doesn't know what type of plastic it is. So no one is rushing to take it off him, despite the fact that these materials cost around £2,000 per ton."

"The first thing he needs to do is identify whether the bumpers are made from polycarbonate or polypropylene," suggests Peter. To do this, he might be well advised to use a Tribopen. This hand-held device checks the electrostatic surface charge of the material. Peter explains: "Every material gives off a charge, even human skin. Because plastics are closer to liquid than solids, their molecular structure is loose and the atoms are pretty active. So they give off a strong charge. Polycarbonates give off a noticeable plus charge and polypropylene has a strong minus charge. Tribopen detects this via its brass head, and the meter inside the device flicks a light switch. If the red light comes on, it's polycarbonate. If the green one comes on, it's polypropylene."

Simple so far, though a breakthrough nevertheless. "So, the man in the Midlands separates his bumpers into two piles and sends them off to the recycling centre. But what if he had a pile of car bits made from 30 different plastics. Now it gets a bit more complicated," explains Peter.

Enter PolyAna, which uses infrared spectroscopy to analyse polymers. "Infrared spectroscopy is a way of identifying a material by analysing the spectrum of light

THE SECRET LIFE OF PLASTICS

reflected off its surface. Shine a stable infrared light onto the material and your detector can tell that certain colours and wavelengths in the spectrum are coming straight back at you, but some are not because they're being absorbed by the material. You record this pattern of reflection and absorption, match it against a chart of materials and their known spectra. Bingo! You know what material it is."

Not so fast – isn't this a laboratory technique requiring you to take a tiny sample of the material, put it in a box and bombard it with infrared before making tediously long comparisons? And isn't it expensive? "Not so," says Peter. "We've come up with a way of getting the infrared ray out of the box, so you can use it on large objects such as intact bumpers. We've built a high-precision optical cell, which contains four flat mirrors for beaming the light in and out of the PolyAna via the plastic surface. The reflected light comes off the surface, into the box and is passed through two curved mirrors to re-focus it onto a three millimetre detector, which records the top-line information. The detector passes the information to a chip which compares it to a database of known materials. PolyAna then types up the name of the material on the read-out. All this fits in a car boot."

Plastic recycling is a tricky business. One small amount of the wrong plastic renders a whole batch useless. Tribopen and PolyAna are set to make the process more reliable and more cost-effective. But Southampton Innovations has discovered that recycling isn't the only application for their latest inventions

"Two other markets are fast emerging," says Peter. "Quality control is the most obvious. Manufacturers can now quickly check whether the materials they are receiving are what their suppliers claim they are, and the other is bench-marking, or reverse engineering. Now you can rapidly analyse the materials used by your competitors. And in the long run, that means keener competition, which has got to be good for the consumer."

RE-TEX

RE-MADE

NW
SKELMERSDALE, LANCASHIRE

RE-TEX™
PROCESSING WASTE INTO
NEW PRODUCTS

TRANSFORM PLASTICS LIMITED

Here's a vision. A plastic tub of strawberry yoghurt. Mmm, nice. But this one has been open for three summer months. Ah. And it's sitting on a rubbish dump. Uuuuu. There are creatures creeping over the peeled-back lid and something that would fascinate a toxicologist is growing up the side. Why? Because at the dawn of the new millennium Britain is still putting the vast majority of its waste into landfill sites. This contrasts dramatically with Germany, for example, which recycles around ninety per cent of its waste. And what's the hardest landfill problem to solve? Dirty plastic.

Recycling plastic is not easy at the best of times, though with PolyAna and Tribopen (see page 71) it is now possible to quickly identify different polymers and recycle them into high-grade materials. But, when you have mixed polymers covered in the gunk their containers once contained, things get even trickier. So it's rather good news that Transform Plastics of Skelmersdale have come up with Re-Tex, a system for converting lively yoghurt pots and their ilk into pillars, posts and fence panels.

Managing director, Paul Samuel: "Europe still has a big problem with recycling plastic because it takes a lot of work to clean and reuse the stuff. It's often simply cheaper to make products out of virgin plastic, but we've come up with a new system which could change that."

Basically the Re-Tex™ process runs like this. Transform Plastics take the dumped plastic, chop it up, and then set off a cleaning system using heat and air to get rid of paper, metal and mouldy old food. Then they make the purified material into new plastic by including additives which make it flexible or stiff, according to the various requirements of the end product. "I have to be able to guarantee structural integrity," says Paul. "Recycled plastic must match its performance against concrete and timber."

Then Transform turn the plastic into underground inspection chambers for under-road drainage systems. 50,000 of these recycled plastic chambers, load tested to 40 tons, sit beneath roads all over Britain with freight lorries trundling over the top of them. Or he uses it to make fence panels and posts. "You don't have to creosote these things – no maintenance at all," he explains. "The posts don't crack, and no rust leaches out. It may cost you more for a recycled plastic panel than a wooden one, but Re-Tex fence panels are greener and last forever."

That is, hopefully, until they get recycled into something else.

DRINKING

Lon

LONDON

THE REMARKABLE
RECYCLED PENCIL
TURNING A CUP INTO A PENCIL

REMARKABLE PENCILS LIMITED

How to make a pencil: take one polystyrene cup from a vending machine; guzzle contents; chuck cup in bin; divert waste from landfill; place cups in Remarkable Recycling Machine – hey presto!

A plastic pencil? How does it write? Very well, thank you – at least as well as its wooden counterpart and even better on some non-paper surfaces. How does it erase? Just as well as the traditional model, and it sharpens even better. But how does it chew? Like the original it can go a bit soggy, but, boon of boons, no splinters.

But why make a plastic pencil? Getting a straight answer out of inventor Edward Douglas-Miller is tricky. "Well, I simply wanted to do it." Yes, but why? Why spend two

years of your life sweating blood over something that might not have been achievable, spending sleepless nights, your own savings (and those of your family), on trying to fly such a crackpot kite?

The answer, of course, is that it is not crackpot. "The market for pencils, pens and stationery is still huge, despite computers," says Edward. "I have always wanted to try and do something that shouts the recycling message out loud. Converting a throw-away product into something ubiquitous and useful seemed to be the perfect message."

Turning a cup into a pencil, that's never been done before. And that is challenge enough for a boffin like Edward. "It really was a difficult problem and I ended up creating a

AND DRAWING

new plastic alloy in order to do it. I wanted to make polystyrene behave like pencil wood. So I'd sit down, work out the mix of materials, send off the specs for manufacture, pay hundreds of pounds for the them to send back some samples, and beaver away at coming up with a means to mass-produce pencils out of the little bit I had to play with."

The hardest task was putting "lead" in the pencil. "I had to find a way of mixing graphite and other writing materials into the polystyrene to produce something that behaved like traditional lead," Edward recalls. "The lead mixture had one melting point, and the wooden sheath mixture, of course, had an entirely different melting point. I had to make a special die in which to blend the two. That day

when I hit on the right formula and extruded a perfectly bonded pencil length – that was my Eureka moment. And then I knew that I could produce this thing. After that it was just another year or so of smaller crises as I tried to develop a pencil that was consistent and stable."

Such is business. Now Edward is making recycled pens and recycled paper. He's even recycling old wellington boots into rubber rulers. He's also set up his Remarkable Pencils factory in Greenwich at the Millennium Dome so that we can all put cups in one end and watch pencils come out of the other. Quite remarkable.

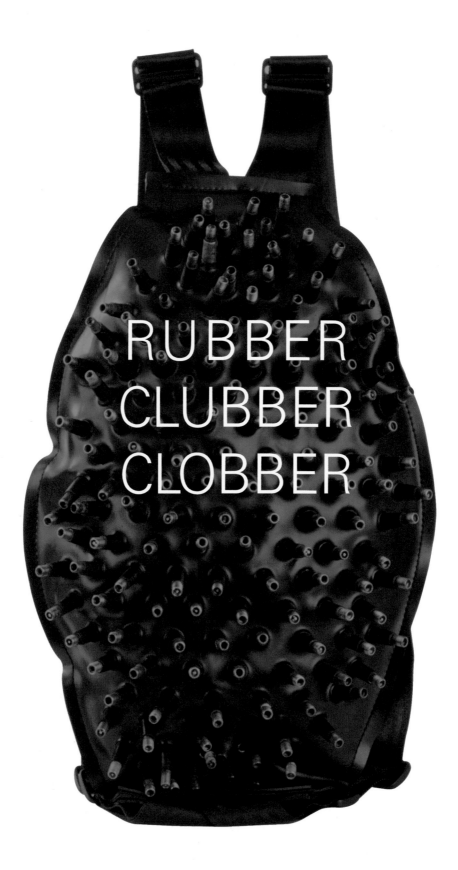

RUBBER
CLUBBER
CLOBBER

SE

HANDBAG RANGE
TURNS A FLAT TYRE INTO A FUNKY BAG

THE INNER TUBE

You have a puncture. You pull out the inner tube. It's ripped. So you fling it in the bin. You fool! You could have made yourself a designer handbag with that!

That's how design graduate Julie McDonagh makes her money, and she's doing very well right now. But, she explains, profit was not her initial motivation: "I came across the fact that in the developing world people invent lots of uses for inner tubes. They make water-carriers out of them, even shoes. Here we're deeply creative about what we do with them. We sling them in the landfill. That's hardly brilliant."

Julie started creating inner tube designs for a project at Portsmouth University, but didn't take it any further until, working for a design company in Reading, she realised that they were selling her designs for lots of money while she was making very little. So she decided to set up on her own, secured a grant from the Prince's Trust, developed the Inner Tube Handbag and took it to the International Spring Fair in Birmingham where, she remembers: "Someone came up to the stand and ordered 1,000 bags!" Julie then realised that if she was to be a serious player she couldn't make all the bags herself, so she found a sub-contractor to manufacture her range.

"I based my Inner Tube range – handbags, rucksacks, luggage and clubwear tops – on botanical forms," explains Julie. "Rubber's very hard-wearing but difficult to work with, but they look like they're made of leather. Now we're making recycled rubber gear ranging from bikinis to sofas, and I even use car seat belts for the straps."

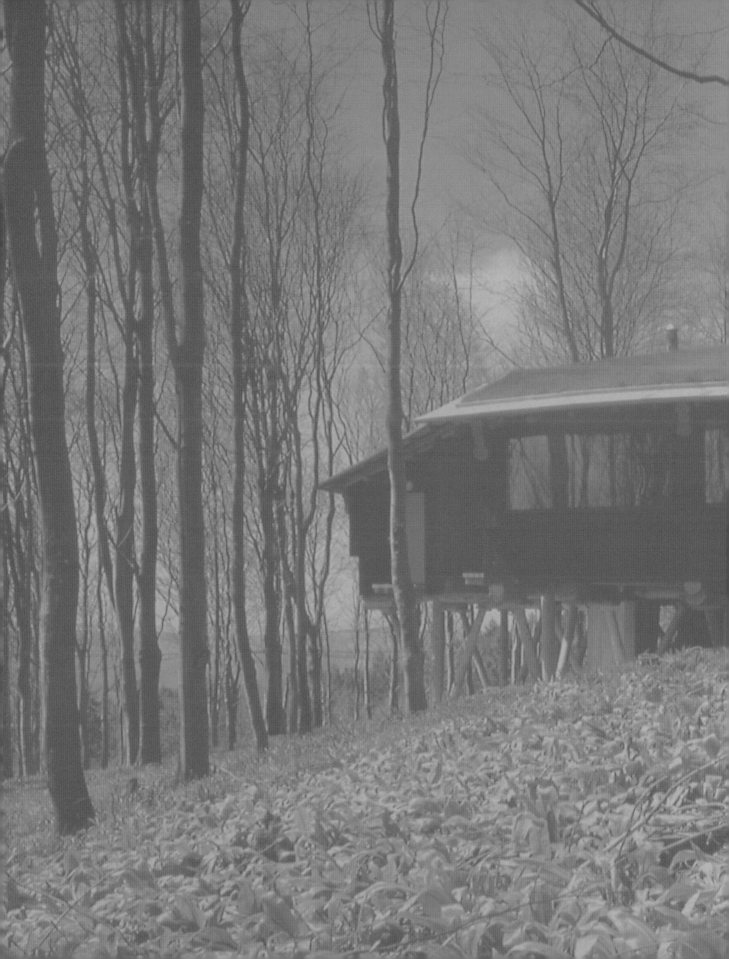

GREEN HOUSES

SW

BEAMINSTER, DORSET

TREE HOUSES
GROWING HOMES
SUSTAINABLY

HOOKE FOREST (CONSTRUCTION)
LIMITED

In this gradually greening world, you might have thought that an educational trust suggesting it really is a good idea to use wood in the construction business might come under attack. But over the last 15 years Hooke Forest Construction has been conducting research into timber's best properties and concludes that there really isn't any better, or greener, construction material. The trick is using wood efficiently.

John Makepeace is a furniture designer/maker and director of the Parnham Trust which has trained a generation of successful entrepreneurs in wood. "Through our research at Hooke Park we realised that we can produce an abundant and sustainable supply of small-diameter timber (5 to 25 cm). Usually it has little commercial value, but we're using it as structural components in buildings."

"We currently import around eighty-five per cent of our timber, which costs billions of pounds a year," explains John. "Most of it is used for construction. Quite simply, we don't have to import all that timber. We can grow it ourselves. And if we did, we'd boost the rural economy and show that well-managed, responsible forestry is the way forward."

But the economic arguments, though powerful, are a side issue. John is primarily concerned with creating houses

that are really pleasant to live in. "There is something about living in a wooden environment that is fundamentally calming and attractive to humans. It satisfies something within us. With wood you can make a dwelling that is extraordinarily beautiful and which raises the spirits. Mental well-being is becoming ever more important, so we need to look at how we live."

Hippie mumbo jumbo? Oh no. John and his team have got it all worked out. "Double curvature in the beams – a series of arches. These can lift the soul." But how? How do you get people to build like this? For a start, building regulations require thick timbers for spans. How do you get around that?

"Building regulations are generated from building performance requirements," John explains. "We are addressing the former, proving scientifically that wood does not need to be used in thick beams to be strong. The key is to use the timber for its best properties – its tension strength and longitudinal compression, rather than as a load-bearing member. By using small-diameter timber and arching the wood, we can use one-fortieth of the timber normally used to support similar weights. Wood has traditionally been used for jobs it's not very good at. Modern material science shows that timber can compete favourably with any mineral-based material."

"Which is better? To cut down a mature tree, haul it, saw it, make it into a laminated beam using all sorts of chemicals, and then use heavy machinery to lift it up into position, or instead make a graceful arch out of three-inch timber, leaping over a 50-foot-wide span? Timber that doesn't have to be cut, hauled, sawn and glued, timber which is taking the load in the manner which nature designed it to do?"

"We use the whole diameter of the tree," continues John. "We generally avoid cutting it into rectangular sections as this weakens it. The technology is energy saving and timber saving, and it's very sustainable. We're building in a world where resources are limited and timber is the only renewable constructional material. The key is not to stop using wood, but to encourage better management of forests and a wiser use of timber. We need to provide incentives to plant and grow more trees, because we need them for themselves. If nothing else, they're great air filters too."

He concludes: "The Tree Houses that have been built so far are acting as technical demonstrations. The aim is to advance the state of the art with a view to improving our quality of life."

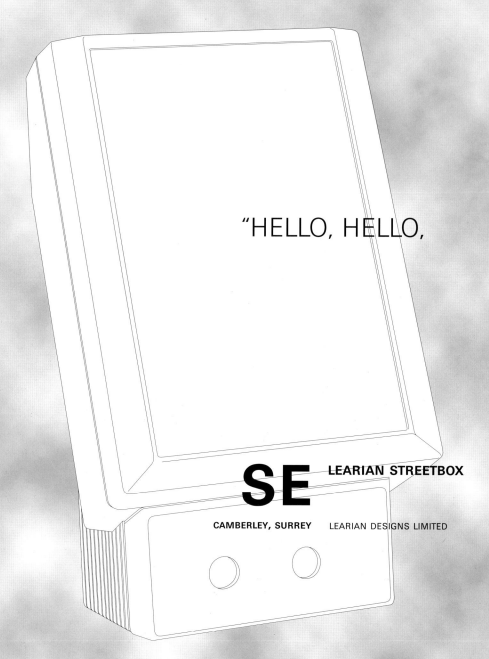

"HELLO, HELLO,

SE LEARIAN STREETBOX

CAMBERLEY, SURREY LEARIAN DESIGNS LIMITED

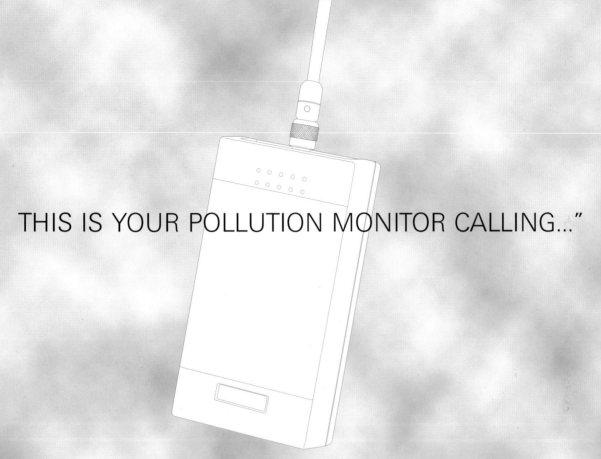

THIS IS YOUR POLLUTION MONITOR CALLING..."

There's a recent European directive which says that local authorities must monitor pollution in their areas. The trouble is, that's an expensive business. You have to set up a number of monitoring stations that are tough enough to resist vandals and sensitive enough to record accurate information at street level. Then you have to go and collect the information. The kit costs money, and collecting and processing the information costs a good deal more.

What if there were a magical system which was compact and mobile, so it was easy to move from site to site? What if it were vandal-proof? What if, instead of having to send people out to read it, the machine broadcast its readings straight to your computer? And what if it were cheaper than existing models, which are the size of a filing cabinet and have to be cemented into the ground? If you were a local authority faced with the new European directive, you'd buy the magical system, wouldn't you?

Well, there is, and they are. The Learian Streetbox, made of double-skinned high impact plastic, is the size of a shoe box and is easily fixed to a lamppost, unlike its bulky predecessors. And by the end of 1999 around 100 units had been shifted to Northern Europe.

Company director Lee Fairbrother: "The Streetbox broadcasts its readings over a range of five kilometres and can run off solar power or mains, which is extremely good news for regional centres. It's easy to move and because it's so inexpensive, you can afford to have a number of them going at once."

The Learian Streetbox is set up to monitor car pollution such as Carbon Monoxide and Nitrogen Dioxide, plus Sulphur Dioxide which comes from fossil-fuel burning. It also records factors that effect pollution levels such as wind speed and direction, humidity and temperature.

SE

OXFORD

**WATERLESS URINAL
SYSTEM**
SAVES WATER, IMPROVES ENVIRONMENTS

WATERLESS UK LIMITED

This is the water-planet. Two-thirds of the globe is covered in the stuff. Do we really need to save water? Yes, because ninety-seven per cent of Earth's water is sea water, which is incredibly expensive to purify. A further two per cent is ice. So only one per cent is available to more than six billion people, plus countless land-based animals and plants. In the West, water consumption per person is rising dramatically as people take more showers and fill more swimming pools. As populations grow, industry spreads and humans consume, some experts are predicting "water wars" in the new millennium.

We need to save water and get used to the fact that it must be conserved, that much is clear. Apart from anything else, it's getting more expensive. Christian Habich is a director of Waterless UK: "The waterless urinal is not just about saving water, it's about saving money. We realise that environmentally conscious products are more likely to be taken up if there's an economic reason for doing so."

How does it work? "The toilet bowl is coated with a repelling gel to which urine cannot stick," says Christian.

"So the urine goes into the filter cartridge which sits over the drain. The filter removes and collects the urine solids – about one per cent of volume – and sends the purified urine down the drain, thereby avoiding the build-up of lime scale. The cartridge is in a slotted casing so as to prevent debris falling down the pipe, and it contains a gel which works like oil on top of water. You can't smell water through oil, however rank it may be. So the urine smell can't get out. The system is odour-free – more so, in fact, than standard urinal systems."

"You save money on water," Christian adds, "approximately £100 per year per urinal. And you save about £150 in maintenance costs, since the pipes don't get blocked with lime scale and solids. With the cartridges costing around £22.50 each and lasting between two and six months depending on usage, it's both cheaper and more environmentally responsible to use this system."

These impressive statistics might explain why Heathrow Airport and the Dome in Greenwich are among the company's growing client list. Ah, could this mean the end of smelly public loos?

THE AIRSEAL SEALANT LIQUID IS BIO-DEGRADABLE, AND THE SEAL-TRAP® CARTRIDGE IS RECYCLABLE

THE PRESS COMES CLEAN

SE

UCKFIELD, EAST SUSSEX

PUREPRINT
WATER & ALCOHOL-FREE PRINTING

BEACON PRINT LIMITED

The chances are far higher now than ever before that, at the end of its life, this book will be recycled rather than dumped as the millennium has ended with a big increase in the use of recycled paper. "Frankly it's a waste of time," says Mark Fairbrass of Beacon Print. "Professionally printed books and papers use the most foul concoction of pollutants. The printing process simply cancels out the good done by paper recycling." Oh.

So what should a conscientious environmentalist do? "Print with the award-winning Pureprint system, of course," says Mark. Pureprint is a printing technique that is about as environmentally friendly as you can get using current technology. Ordinary presses use large volumes of water and a lot of solvent. You have to wet the printing plates and keep them wet; only, the trouble is that water is too thick for the printing process. So you have to thin it down with IPA, a type of industrial alcohol that's considered to be a dangerous carcinogen and one of the worst modern pollutants. It gets in the air, is breathed in by the operators and people living nearby. Then it drains right back into the eco-system.

Pureprint doesn't use any water at all, and certainly no IPA." (We'd better make this clear...this IPA bears no relation to that fine alcoholic beverage of the same name – Indian Pale Ale.)

This new printing system, developed in Japan, has been taken a stage further by Beacon Print, and it's their extra environmental emphasis that makes Pureprint so unique. "Pureprint is not just what happens on the presses, it's about the fact that we emphasise the environment in everything we do," explains Mark. "We use a chemical-free system developed in the USA for all our filmwork. All our vehicle deliveries are computer-planned, ensuring that vehicles are on the road for as little time as possible. The environmental message runs through everything we do, from car-sharing to getting people to and from work, to the paper and packaging we use. We're offering what is, literally, a clean service."

It may cost between seven and ten per cent more to print with this company, but there are other advantages. "The quality is better," says Mark, "and the pictures are sharper, with stronger, brighter colours, because we are using a cleaner process. It's why the blue chip customers, who started with us because they had an environmental conscience, keep coming back."

CONVENTIONAL WEB OFFSET PLATE

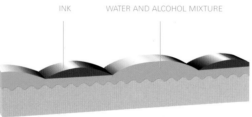

INK WATER AND ALCOHOL MIXTURE

A TYPICAL PRINT-RUN USING THE CONVENTIONAL METHOD NEEDS OVER 60 LITRES OF RAW ALCOHOL AND 600 LITRES OF WATER

PUREPRINT
WATERLESS PLATE

INK SILICONE RUBBER LAYER

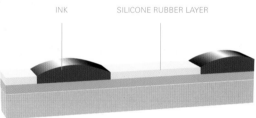

THE PUREPRINT METHOD PRODUCES
SHARPER RESOLUTION AND
IMPROVED COLOUR CONSISTENCY
AND IS ALCOHOL AND WATER-FREE

ODOUR EATER

E

SIAT SURFACTANT INDUCED ABSORPTION
TECHNOLOGY - AIRBORNE 10

REMOVES TOXIC GASES
ECOLOGICALLY

**PETERBOROUGH,
CAMBRIDGESHIRE**

ADVANCED CLEAN AIR TECHNOLOGY
LIMITED

Does something near you really pong, I mean really stink, like a chemical works, a landfill or a sewage works? We all know that the smell of human waste is deeply unpleasant. Which is just as well because it's meant to discourage us from having anything to do with it. But what happens when you live near something really smelly?

Well, what happens is the installation may (or may not) spend enormous amounts of money trying to filter the smells away. These expensive systems don't always work, and every so often, when things aren't going quite right, it's time to reach for a clothes peg. But now there is a simple and more effective way to kill those smells.

Phil Hutchings is managing director of Advanced Clean Air Technology: "There have been a series of systems on the market that use fine mists to mask smells. They don't have a great reputation. People turn their noses up at them. But Surfactant Induced Absorption is different.

"Surfactant changes gases into liquids by absorbing them into the water droplets of a mist. Liquids have no smell – the only odour comes from gases escaping from them. So, trap a gas in a liquid and you can't smell it. Water droplets can absorb toxic gases – as 'acid rain' demonstrates only too ably. Surfactants work to improve the absorbency of water by half a million times."

So you spray a mist of enhanced water over a sewage settling tank and it absorbs the smell? The gas molecules impact with the water droplet and are locked in. This is far better than masking the smell, which really means creating two smells, or spending money to vent it away.

"The other good thing about the surfactant approach is that it's not selective – it will quickly absorb almost any gas," explains Phil. "The surfactant actually strips the water droplet of its surface tension, which allows more rapid absorption. At one end the droplet is hydrophilic, attracting water-loving gases, and at the other end it's hydrophobic, attracting gases that hate water. Then, the odourless droplets enter the soil where they act as fertilisers, being quickly broken down by soil bacteria."

Well this sounds fine for natural gases. But does this system cope with toxic gases? "Certainly," says Phil. "You pass the toxic fumes through the mist and then extract the mist to recover all the chemicals, that could possibly be recycled."

The other advantage of this system is that it may be mobile. "We've just been asked by a water company to treat 20,000 tons of sewage cake that is sitting in the middle of a field. We've come up with a mobile system that requires no mains power."

"But the real beauty of the system is its cost," says Phil. "It depends on the application, but SIAT may be just one-twentieth of the price of a scrubbing or carbon filter system, and it operates at a tenth of the cost. Our client list is growing all the time with turnover doubling almost every year. Currently it's being used by the chemicals industry, landfill sites, bakeries, restaurants, sewage works, composting and mushroom farms – any place where odours are causing people to complain. And no one else is offering this cost effective technology."

DON'T ADD WATER

SW

BIOGRAN
SAFE COMPOST FROM SEWAGE

BRISTOL WESSEX WATER

πWhat can we do with our poo? What should be done with our dung? It's a question that's bothered mankind ever since we began to live together in large numbers. Solutions have varied over the centuries from, "chuck it out the window", to "dump it in the North Sea and let the tides take it away to our neighbours". Neither tactic goes down too well.

"Put it on the fields" is another common cry, but as Paul Williams, UK director, put it: "Talk to people about sewage fertiliser and it conjures up the image of some bespattered bowser spraying foul-smelling liquid all over a field on a sunny afternoon." Enough said.

What we should do, as we all know but cringe at the thought, is recycle it. But how? Paul has an answer: "Remove the water from the sludge. Turn the remainder into granules. Dry the granules and then put it on the land." So Wessex Water has started producing Biogran, which is exactly that – dried human poo that makes excellent fertiliser.

"The granules are virtually odourless and, because they've been dried at an air temperature of 420°C, they're totally environmentally sound," he advises. "Around fifty per cent of each granule is organic which is ideal for soil-formation, since it generates a slow release of nutrients. It's a very environmentally-friendly soil conditioner."

Before 1999 the granules were produced by Wessex Water's one and only Swiss Combi Technology drier in Avonmouth, and that used to produce more than enough. But since the water company decided that Biogran is a seriously marketable product, they can't produce enough of it. Two more driers are opening, one in Bournemouth, the other in Weston-super-Mare.

"We've more than doubled our capacity," explains Paul. "Farmers are buying it, and people who are restoring and regenerating land are buying it in even larger quantities. We've got clients who are landscape contractors and golf course owners, and we think that sports venues are likely to prove to be big customers."

JUST ADD FUNGUS

THE BIO-LOGIC PROCESS

BACTERIA

FUNGI

COMPLEX LIGNIN MOLECULES

CARBOHYDRATES, PROTEINS, ETC.

— ORGANIC DEBRIS $=$ $CO_2 + H_2O +$ ENERGY

Sc

**BIOREMEDIATION OF
CONTAMINATED LAND**
POLLUTION-MUNCHING BUGS

GLASGOW BIO-LOGIC REMEDIATION LIMITED

The government says that most new houses should be built on reclaimed brown-field sites. The aim is laudable – we clean up existing land and then reuse it. But how? How do you clean up the site of an old oil refinery or gasworks, making it safe for people to live and work on?

The traditional method is called "dig-and-dump". The contaminated surface soil is bulldozed up, loaded into lorries and trucked away. This contaminated convoy sometimes has to travel across the country to find a dump that will take it. So, this immense exercise doesn't solve the problem – it simply moves it.

But now there is a better way. Robin Mackenzie, a remediation engineer with Bio-Logic Remediation, says: "The method we use is successful because it's very economical. In most cases it's considerably cheaper to use our method than the old dig-and-dump."

"What we do is excavate all the contaminated soil into long rows, or biopiles, around 1.8 metres high and 3 metres wide, in a special on-site treatment area," explains Robin. "We then use machinery to condition and aerate the soil. We introduce a special mix of fungi which kicks off the bacteria in the soil. Then the sludge-munching starts. The microbes eat the carbons and hydrocarbons, and convert them back into CO_2 and water. Petrol, diesel, oil-based paints and coal by-products all get cleaned away. It's an organic process – no chemicals are involved."

Decontamination times vary. Last year, the company completed decontamination work near the Dome at Surrey Quays, cleaning up 2,000 cubic metres of soil in less than 40 days.

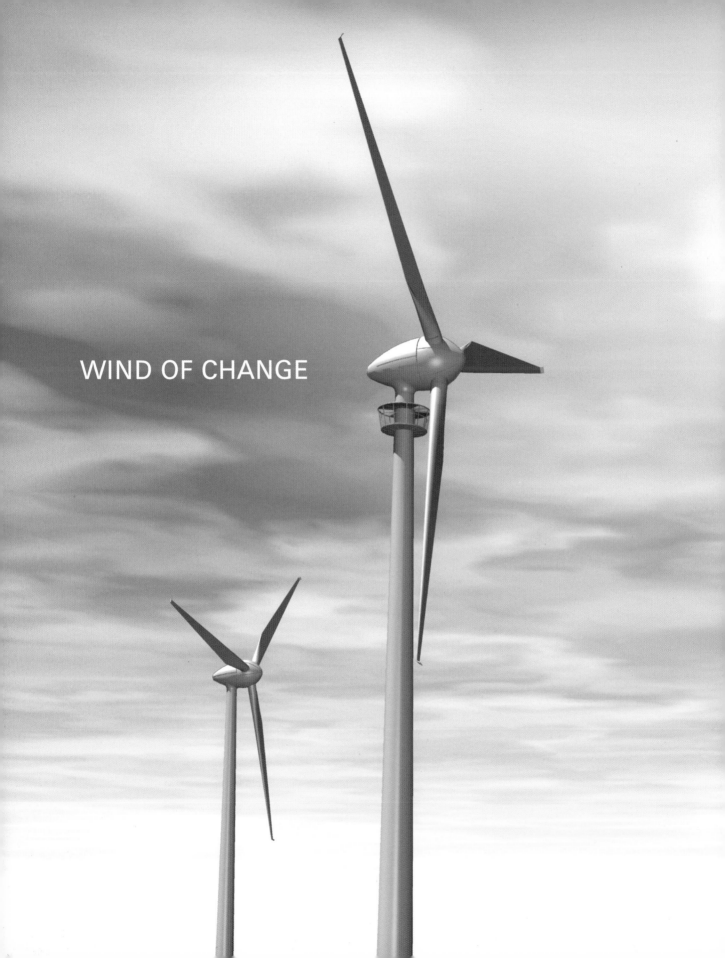

WIND OF CHANGE

Lon

ENERCON E-66 WIND
ENERGY CONVERTER
RE-ENGINEERING THE WINDMILL

FOSTER AND PARTNERS, ARCHITECTS,
DESIGNERS & PLANNERS

In the 1970s there was panic in the energy industry as fuel prices spiralled and the media began to spread the fear that oil was likely to run out sooner rather than later. Now, in the third millennium, those fears are here to stay. Though new technology looks set to make the extraction of oil more efficient (PowerDrive, see page 161) and its consumption less prolific (Trent, see page 173), fossil fuels have been linked, beyond any doubt, to global warming. The only answer is to adopt viable alternatives.

But who's going to put serious money and research into developing economically viable alternative energy systems? Architects? Of course, architects!

Kevin Carrucan is an associate of Foster and Partners: "We have a clean sheet of paper and an open-minded approach towards problems. We believe in the integration of man and machine, nature and science, engineering and art, and the E-66 is a perfect example of this. We've created a sculpturally beautiful, scientifically advanced wind generator which can supply 1,200 homes with non-polluting, renewable energy. After around 20 years, the equipment will have paid for itself and, therefore, future energy is free for as long as the equipment lasts."

Quite a claim. How have they done it? Kevin explains: "We've drawn on the synergy of Foster and Partners, using skills from across the company, and from within Enercon, to create the Enercon E-66." The E-66 stands around 100 metres high. Its turbine blades are over 66 metres in diameter. The mast is tapered towards the top, which makes it more elegant and is sensible from a load distribution point of view. The wings have special tips, rather like those on the wings of a 747-400 aeroplane, which reduce turbulence, making the E-66 much quieter than other turbines.

So far, 140 E-66s have been installed in Europe. The first UK installation, which features a specially designed viewing platform, went up last summer in Swaffham, Norfolk and is whipped by winds from the North Sea. Taller than an office block and at £2.5 million it's unlikely you'll have one in your back garden. But the technology advances contained in the design represent an important step forward in the hunt for fossil-fuel alternatives, and may in the future be applied to domestic products.

COW HEAVEN

1. TRIM AND THOROUGHLY CLEAN THE CLAW. WIPE WITH ACETONE OR METHYLATED SPIRIT. CLAW MUST BE DRY.

2. TRIAL FIT THE SHOE BEFORE APPLYING ADHESIVE. SOME TRIMMING OF THE CLAW MAY BE NECESSARY

3. WEARING GLOVES, THOROUGHLY MIX THE ADHESIVE WITHIN THE SHOE TO ACHIEVE AN EVEN CONSISTENCY

4. FIT THE SHOW ON THE COW'S HEALTHY CLAW

NI

BALLYCLARE, ANTRIM

COWSLIPS+
ORTHOPAEDIC SHOES FOR COWS

GILTSPUR SCIENTIFIC LIMITED

Imagine that you have a blister on your foot. A big blister. Now imagine that you are very fat and your feet are very small. Oh, and you have four of them. And you spend your days standing in a damp field or concrete yard with no shoes on. But you're not very bright, so you keep putting your weight on the dodgy foot. This loads the pressure on the blister which gets torn and ground into the dirt and muck. Silly cow.

You can't tell her though. It's no use yelling, "Lift your foot up!" She just doesn't listen. The result is that she (or he, because it happens to bulls too) spends a lot of time in pain, the infection never heals, milk yields drop and vets' bills rise.

Veterinary surgeon, Dr Ernest Logan, has come up with a solution that's so simple, it's almost beautiful. "Plastic slippers for cows. Why shouldn't cows be comfortable?" he asks. Indeed, and so successful has he been in improving life for cows, that the Royal College of Veterinary Surgeons awarded him the Livesey Medal for the most serviceable work by a vet in prevention of pain or fear in domestic animals.

"The idea is pretty simple. If you can support one of the hooves a little higher off the ground, the injured foot won't touch the soil. Thus they suffer less pain and the wound heals quickly. Before Cowslips+, farmers would glue wooden blocks to the hooves. But these were too easily

knocked off. In fact I got the idea for Cowslips+ from one that had fallen off. The adhesive had formed a plastic-like clog or a slipper on top of the block. I thought that if these were made of plastic, with an upper portion coming up over the toe, they would stay on more easily."

"I made a papier-maché shoe which a friend in the Industrial Science Laboratory in Northern Ireland used as a template to make me some prototypes that I tested on lame animals. I decided to produce Cowslips+ by sub-contracting to a manufacturer, and then getting another company to market and sell the idea. But I realised that this route would make the price too high for many farmers, which made it all pretty pointless. So now I market Cowslips+ myself."

"The first manufacturer was so impressed with Cowslips+ that he wrote about them for a manufacturing journal," recalls Dr Logan. "The story was picked up by people in the world of agriculture. Before I'd even begun to think about orders I had 300 inquiries, and I still hadn't worked out the price or what glue I was going to use."

Dr Logan took the product to agricultural and veterinary shows. News spread, sales soared and now Cowslips+ are available all over the world. "It would be nice to say that I had conducted a brilliant marketing campaign," says Dr Logan, "but the actual truth is, the product is so good that it sells itself!"

5. POSITION FIRMLY BY TAPPING THE TOE OF THE SHOW. THIS ACHIEVES THE IDEAL POSITIONING. SOLE OF THE SHOE SHOULD BE PARALLEL TO THE SOLE OF THE CLAW

6. CLEAN OFF ANY EXCESS ADHESIVE

7. LEAVE FOOT IN RAISED POSITION FOR SEVERAL MINUTES UNTIL ADHESIVE HAS SET

8. PLACE FOOT ON GROUND AND KEEP THE COW STANDING FOR A FEW MINUTES. THEN THE COW IS FREE TO WALK UNINHIBITED

COMFY CHEWS

SE

CRANLEIGH, SURREY

WATERBEDS FOR QUADRUPEDS
FOR A CLEAN & COMFORTABLE STALL

ALANTA LIMITED

In parallel with a career in the helicopter and airline business, Alan Bristow has a passion for designing, developing and marketing unlikely inventions. His latest, Waterbeds for Quadrupeds, was prompted by his lifelong commitment to improving the welfare and breeding of pedigree dairy cows and bulls.

So where did the idea for Waterbeds for Quadrupeds come from? Alan Bristow: "I was visiting a friend in hospital who had a serious back injury, and his treatment involved lying comfortably on a waterbed. The second time I visited my friend, it dawned on me that the excellent qualities of comfort and hygiene inherent in the hospital's waterbeds might be developed to radically reduce the cost of buying in straw bedding, priced at around £25 per ton, for 400 milking cows and their progeny."

"Knowing how conservative most dairy farmers are, I started off by experimenting with the well-proven heavy duty rubber mats used to insulate concrete stalls during the winter," recalls Alan. "I laid two together, non-slip surfaces upper-most, sealed them watertight, and injected sufficient water to allow a 700 kg cow to float comfortably. That was installed in a recess next to a straw-bedded area housing 85 milking cows. After a while a young heifer sauntered over, gave it a sniff and settled down."

"We watched her behaviour day and night, until during the ninth day, her bed was invaded by a much bigger, older cow, who turfed out the heifer. News spread and, 48 hours later, the boss cow turned up and took up residency for the winter. I wasn't surprised to see the boss cow take her place at the top of the pecking order. The first thing I do in a hotel room is check the bed for comfort...animals are just the same!"

"Apart from the fact that it's reassuring to see comfortable, contented, clean cows, the waterbeds bring other benefits. They've cut my vet bill in half. It's much easier to hose down a line of waterbeds than muck out a straw-covered yard, so they reduce labour and, unlike straw, they don't harbour bacteria. The waterbeds are in fact self-draining to prevent puddles of muck building up. My milk production has gone up about six to seven per cent because the cows spend 14 out of every 24 hours chewing the cud more effectively because they're relaxed."

With an estimated lifespan of at least 15 years, Alan reckons that the average dairy farmer will recoup his investment in Alanta Waterbeds in just two years. After that, it's all gain. Alan's design company, Alanta Limited, has granted patents for the EEC and USA, and a licensing deal with Dunlop-Enerka Group Limited means that Waterbeds for Quadrupeds are being manufactured in Holland, the USA and Australia, and marketed world-wide.

OYSTER ROISTER

NI

NEWCASTLE, DOWN

ROTOR
TIDAL WATER-WHEEL FOR
TURNING OYSTERS

DUNDRUM BAY OYSTER FISHERY

Oysters. The food of love. Or a bit like a mouthful of sea water. Well, whatever turns you on.

On the rivers of Britain, from the marshy mud banks of Essex to the sandy flats of County Down, oysters are farmed as they have been for hundreds of years. And business is booming.

Robert Graham of the Dundrum Bay Oyster Fishery: "Well, they used to use horse and cart, and on mud-flats you still have to use boats and boards, but now we go out in a tractor and trailer at low water to tend to the oysters. They need a lot of attention in the first growth season. And as the business expanded, I had to use more and more people, because we've only got a few hours before the tide comes back in."

Traditionally you grow oysters in mesh bags about one metre by half a metre. The bags are supported on trestles and are regularly turned over by hand. This stops the seed growing together, and discourages algae forming which chokes the water flow and food supply.

"The problem was that I had difficulty in keeping on top of the amount of work," recalls Robert. "I started thinking about automating the process and figured out that there must be a way to use the power of the rising tide to create a turning action which would shuffle the oysters.

Another problem was the flat shape of the existing oyster bags. They had corners where the oysters could get jammed and wouldn't be turned."

The system Robert came up with is so simple it could have been built hundreds of years ago. "Well, it's a barrel really, lain on its side, with slots that allow you to slide in mesh containers which hold the oyster seed," he explains. "The tide comes up, lifts a float and cranks the drum round a quarter turn each tide. It's made of plastic and stainless steel, and you don't really have to touch it until you harvest."

"I'd never built anything like this before, though I used to be a maintenance engineer in a steel works so I was pretty good at practical things. But building this was always two steps forward and one step back. The breakthrough came when I built a working model, put some oysters in it, and got spectacular results. The quality of the oysters was superb – they all had a uniform shape, a deep shell, they grew quickly and the meat content was lovely. It really inspired me and kept me motivated."

Now Robert's selling the Rotor at aquaculture shows. "The big attraction for oyster farmers is the saving in effort. It also allows them to buy smaller seed at a considerably lower cost, and still produce a greater percentage of high quality oysters."

CAUGHT YELLOW-HANDED

WMid

TELFORD, SHROPSHIRE.

SMARTWATER
MARKING & TRACKING
VALUABLES

SMARTWATER EUROPE LIMITED

Phil Cleary was a police officer in the Midlands police force and he was getting increasingly frustrated. "One particular case got to me," recalls Phil. "I went to investigate a burglary at an electrical shop. The place had been broken into several times, and so I expected to meet a man hardened to crime. But the guy was almost in tears."

bed was a brand new camcorder. So we locked him up and did the good cop/bad cop routine. But he just looked straight out the window and asked for a lawyer. He was well-versed in the law of the land, and at just 15 he was the oldest member of the gang. We showed the shopkeeper the camcorder. He said, it could be mine, but he could have stolen it anywhere. So we had to back off."

"I felt bad about that case because my Dad had been a shopkeeper," explains Phil. "There had to be something that would stop this burglar in his tracks, something that would make him think twice. I had a car accident shortly after that, and during my convalescence I came across the famous case of Regina V Pitchfork, in which a murderer and rapist was identified by DNA samples. Rape instances actually fell following publicity around the case, right across the country. Why? Because the DNA test was a new scientific technique and it worked as a psychological weapon, a deterrent, against rapists. I discussed this with my brother Mike, who is a research scientist. He then worked in his garage to develop SmartWater."

SmartWater is a harmless chemical which you can paint on goods. It can't be seen, but when tested for, it

reveals a unique "fingerprint" special to the owner. There are literally billions of possible variants. Now a customer can buy a personalised version of SmartWater and paint it on his goods. If they are stolen he'll be able to prove in a court of law that they belong to him.

SmartWater is configured to glow bright yellow under ultraviolet light. The idea is that burglars are sprayed with the compound as they enter the building. They've been marked, and it lasts for months. If they are pulled up by the police, the yellow glow can easily be spotted under a UV lamp, and then the forensic scientists can identify the chemical fingerprint and so prove the burglar's connection.

SmartWater is now produced under the aegis of the Home Office Forensic Science Service and is in use around the country. Crime prevention officer Colin Pearson of Durham Police: "This is a very effective system. We're working jointly with the local education authority — they've put ampoules of SmartWater in all their schools, and stuck information stickers in the windows warning any potential theives that school property is marked with SmartWater. We believe that this innovative deterrent is helping in the fight against crime."

IRIS RECOGNITION
SECURITY VIA NATURE'S DIVERSITY

CAMBRIDGE **JOHN DAUGMAN, UNIVERSITY OF CAMBRIDGE**

PERSONAS ATM WITH IRISIDENT
NO MORE PIN NUMBER

DUNDEE **NCR FINANCIAL SOLUTIONS GROUP LIMITED**

You walk to your front door. It looks you in the eye, and opens. Science fiction madness? No. It's happening today, all because of John Daugman's work at Cambridge University.

As long ago as 1936 it was realised that the patterns in the human iris were, like fingerprints, unique to each person. Since then the idea has had several outings in science fiction, and there have been a number of attempts to formulate algorithms which recognise the patterns. But it proved too complicated until the task fell to John. "I was fascinated by the mathematical problem: how to describe and classify random patterns."

By doing some mind-boggling maths, John has created a way to mathematically represent the iris pattern, which means that digital technology can interpret and recognise the information. In 1994 he patented the software and is now busy granting licences to a growing list of companies who are fascinated by its performance, and its multiple applications.

The possibilities are legion. Throw away your keys, cast your credit cards aside, all you need is a nod and a wink at a discrete camera. Think about it, you'll never have to hunt for those lost keys or ID cards again.

One of the first companies to run with the technology is NCR Financial Solutions Group Limited, based in Dundee, Scotland. The PersonaS hole-in-the-wall cash machine doesn't require a pin number. Instead, two discrete cameras positioned behind the screen scan the user's eyeballs, looking for the unique characteristics of the coloured portion of the eye. The system has been on trial at the Nationwide Building Society.

So, do remember to clean your contact lenses before you go to the cash-point. Who, at the end of 1899 could have made any sense of that statement? Even in 1989. The world gets weirder day by day...

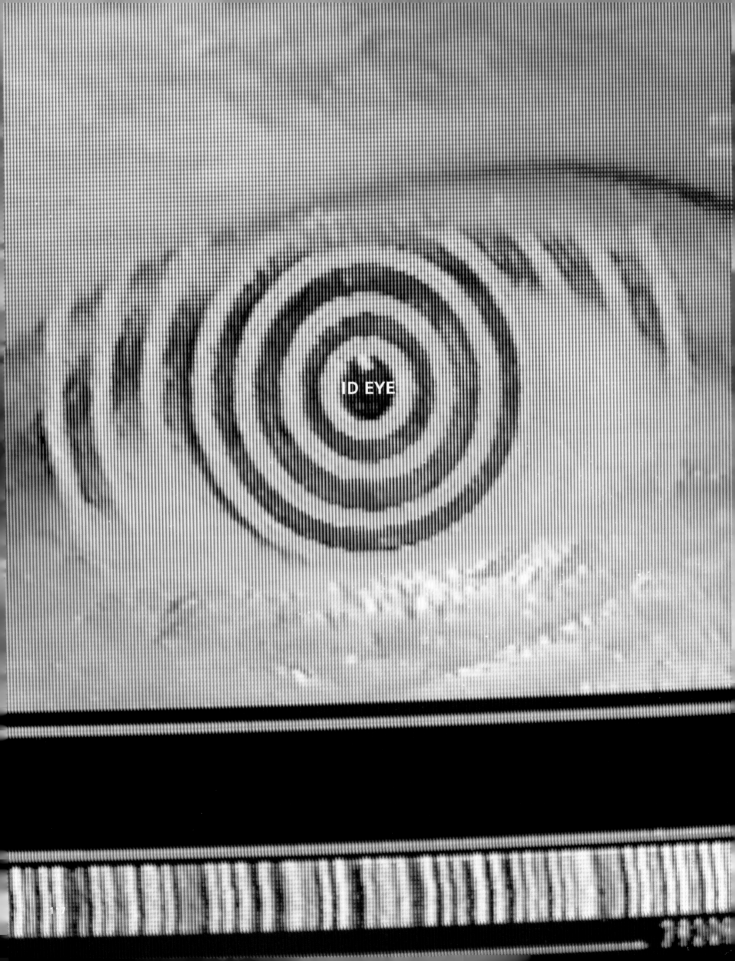

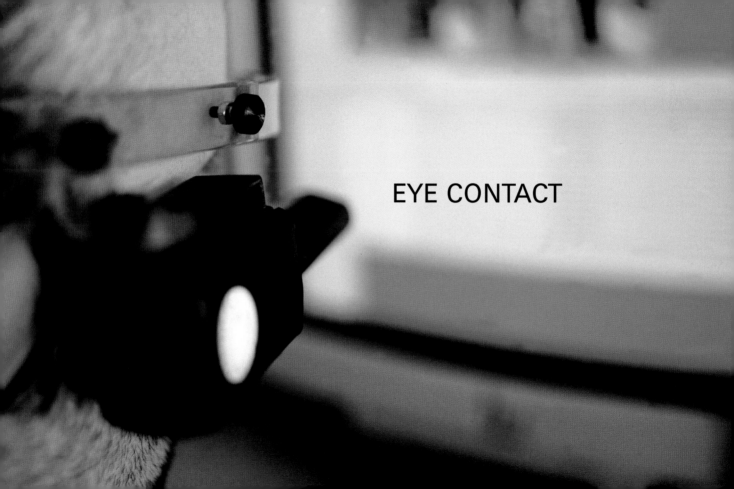

EYE CONTACT

E

VCS
MULTI-USE EYE-TRACKING SYSTEM

OLDHAM, LANCASHIRE FERRANTI TECHNOLOGIES LIMITED

It's night-time and you're driving through the winding lanes of Devon. You're approaching a left-hand corner. Your right foot is covering the brakes and accelerator. Your left foot is on the clutch. Your left hand moves the gear stick as your right hand pushes the wheel round. Then there's a burst of light – a car comes around the corner from the opposite direction, and you've run out of limbs. You can't dip your lights. Then you remember. Your car is fitted with VCS. You move your eyes slightly, and the lights dip.

VCS is Ferranti's Vision Control System. Not available on cars yet, it is a technology that uses your eyeball as a control mechanism. So if you want something to happen to something – all you have to do is look at it.

"The most obvious applications are in aviation," says head of sales and marketing, Stephen Warren. "Pilots are very busy when they're flying jets, and for military applications, to be able to target an attacking aircraft just by looking at it could give you a definite edge." You could call Stephen a master of understatement.

What marks the Ferranti VCS out from the competition is that it is a small, comparatively unobtrusive unit. "Most similar eye trackers require your head to be strapped to a table. A trifle inconvenient if you're flying a Tornado GR-1 through mountain terrain."

How does it work? Stephen explains: "The VCS consists of a small head-mounted unit that shines a low-powered infrared light into the eye. This is totally harmless – there's less UV in it than you experience from ambient sunlight. The light reflects back from the retina into the VCS where it is collimated (focused) down to a spot of light that falls onto a photo diode array. As the eye moves, the spot moves around on the array, and there's a chip loaded with algorithms which works out the eye's position from the position of the spot on the array. So the direction you are looking in is now monitored by the computer. Move your eye and you can trigger control systems that apply brakes or turn on switches."

But there are other applications for this technology. "We've been conducting trials with people who are paraplegic," says Stephen. "They are able to use eye movements and voice commands to operate a range of equipment, including word processors and, possibly, vehicles. Eye-movement and voice activation are likely to become one of the principal ways in which we interface with computers. Another important application will be for training aircraft crew, by making sure that they are scanning their instruments properly and in the right order."

BANDWIDTH BUSTERS

SE

SOFT CD
UPDATES CD-ROMS
VIA THE INTERNET

NEWBURY, BERKSHIRE IORA LIMITED

You're a giant manufacturing company. You want to send out your latest price list for hundreds of products. You also want to alert your customers to new products. And more than this, you want to supply updated technical information on them all.

In the old days (circa AD1995), you'd have produced a brochure that would be out of date before it was printed. Today, you have two new choices. So, you make the information available via the internet, or you send it out on a CD. Both present problems. The internet is slow and it takes hours, sometimes days, to download large files. CDs are faster, but can be expensive to produce and lack the instant communication facilities which the net can offer. So it's time to combine the strength of both media and the best of both worlds.

Paddy Falls, Brian Collins, Steve Draper and John Roper have spent 10 years in the network software business. They were good at what they did and, as with so much British talent, they faced a choice. Start up on their own, or take a plum job in Silicon Valley, USA. They wanted to stay in the UK. So they had a great idea and formed iOra Limited to get it out there.

"OK," says Paddy Falls. "You send out your CD and then, six months later you want to update it. So you tell your customers to 'double-click' on the SoftCD link file. This file knows where the updates are on the web. It logs onto the web and downloads the compressed version of the update. It zips into everyone's PCs and sits on the hard drive. When the CD plays, the computer picks up the new information on the PC and presents it to you. To the user, it looks and feels like the CD has been updated. It's a unique product solving a lot of problems. It means you haven't had to send out a whole new CD, and you haven't had to try and download a CD's worth of data."

But as the net gets faster, won't this SoftCD solution become unnecessary? "The net is getting faster, but it's not speeding up at the same rate that hard drives and disks are increasing their storage capacity," explains Paddy. "A DVD holds seven times the volume of a CD. But the speed at which you can download from the net (measured in bandwidth), has only doubled or trebled in the same period. Even using the ISDN, information is taking far too long to download. Pages of information, which might once have contained about five kilobytes, are now loaded with visuals and may contain more than a megabyte."

Customers for SoftCD tend to be large organisations, like Shell or the Association of Credited Chartered Accountants, that have mobile or remote partners and customers who constantly need up-dated sales, technical and support information. Other opportunities are coming with the increased use of mobile wireless technology, for which the bandwidths are even smaller. They operate at half the speed of today's wired modems. "And Europe is at the centre of this new mobile technology," points out Paddy. All the more reason for going Soft.

MINING FOR INFORMATION

SE

WOKING, SURREY

CLEMENTINE
MAKING SENSE OF DATA

SPPS (UK) LIMITED

It was once believed that everything was knowable, that it is just a question of numbers, and if you had sufficient information about the universe at your fingertips, you could predict the future. Since then, the Uncertainty Principle of Quantum Mechanics, which suggests that we can't even be sure of the location of the most basic particles (so what hope for accuracy with larger systems), and Chaos Theory, which proposes that big systems are too complex and random to be predictable, have hammered nails into the coffin of futurology.

But there is creaking in the crypt, a scraping sound. The coffin lid is sliding aside. And up rises Clementine. The daughter of that old American prospector lives again and she's digging for gold.

Chi Tang, UK marketing manager at SPPS: "Clementine is a sophisticated data mining tool that uses neural networks to create a form of artificial intelligence. This means that Clementine will study trends, graphs and figures 'intelligently' and dig through your data to come up with the most likely outcome. And it generates the best possible calculated guess."

"Let's imagine it is trying to predict a football result," suggests Chi. "Clementine will analyse the two teams. It will look at all possible influences on the outcome, from the form, fitness and mood of individual players, to the fans' recent levels of support. It will look at likely weather patterns and the team's performance under various conditions. It will consider the economic fortunes of the clubs. It will take into account recent score-lines, and their effects on each individual player and the crowd. And from all this, and much more, it will conclude which team is the most likely to win, and the possible score. This approach can't take into account freaks of nature – the lightning bolt from the sky or the injury to a key player – but it can give you, more accurately than ever before, the most likely outcome."

Of course, the prediction is only as good as the information that is entered on the system. But this is where Clementine beats similar data mining tools. "It is set up to run on Microsoft Windows and uses layman's terminology," adds Chi. "Previously, to use this sort of software, you had to be a heavy-weight statistician. Now it's much easier and cheaper for smaller companies to make use of such

software. This software brings server capability to everybody's desktop."

"Clementine is excellent at identifying patterns and trends. Its main business use is for predicting future sales. You take all the information at your disposal, about the market, your product, costs, marketing campaigns, public response, the product's previous performance in that market, your competitor's performance, etc., and then you number-crunch. What comes out at the end is the best possible prediction of how many sales you'll make. This works to make your company more efficient and focused. It can create a brilliantly vivid image of your company as a whole."

The key to this software's effectiveness lies in the mathematical algorithms known as neural networks. "The algorithms cause your PC to mimic parallel processing, which is currently the most powerful and efficient form of computer calculation," explains Chi. "An algorithm is like a multitude of looped mathematical functions that search for a result and will keep going until they identify the best possible solution. The algorithms work together to analyse

a numerical representation of the past and build a pathway for you to follow, based on the information gathered. New algorithms are being generated all the time and each one is better than the last at recognising patterns and predicting the future."

So how long before people are using Clementine to beat the bookies? Certainly Clementine can reduce the odds. But many gamblers work on gut instinct. They say human intuition is more user-friendly. The down-side is that intuition isn't exactly quantifiable or reliable.

PLAYING GOD

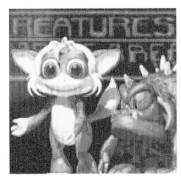

CREATURES
SOFTWARE SIMULATION
OF COMPLEX BEINGS

CAMBRIDGE CYBERLIFE TECHNOLOGY

DO YOU BELIEVE IN PIXELS?

It's life, but not as we know it. Cyberlife Technology took the world by storm in the late 1990s with Creatures, a new form of computer game made up of characters which behave like "artificial life". They are "born" with 300 characteristics, ranging from physical appearance to sex. You can "talk" to the Creatures, and teach them to eat, drink and meet other Creatures. As they breed they become more complex because they have the capacity to learn from their computer environment and pass on what they've learned to new, improved generations, in a mirror of genetic behaviour, using simulated brains, biochemistry and genomes.

This "artificial life" technology has applications in a wide range of computer simulations and robotics. Howard Newmark, publishing director: "DERA, the Defence Evaluation Research Agency (FireAnt, see page 31), have commissioned us to create a simulated military aircraft controlled by an artificially intelligent organism. These UCAVs, or unmanned combat air vehicles, offer savings in risk to life, cost and weight."

"We are also using our technology to create Bioengines, which simulate bacterial growth," explains Howard. "The idea is to come up with a means by which pharmaceutical companies can do some drug testing on computers, rather

than with laboratory or living specimens, by simulating how bacteria, like E-coli for example, will react to new drugs. It could turn out to be a much safer way of testing new drugs."

For the computer gamer, the future is definitely weird. "We are field-leaders in Emergent Game Play," continues Howard. "This is a new type of game, designed for the internet, in which we give you the tools and you make a game emerge from it. For example, go onto one of our sites. You are now a character on a strange shore, in a world populated by Creatures of one form or another. What do you do? Build a shelter? Explore? And every so often, something you haven't planned for will happen as cyber-nature throws a curved ball at you – much in the way that real nature does."

"The excitment will be that other players are able to access your game in various guises. Is the character with shape-changing ability a computer-generated Creature or a human being? It's going to be difficult to tell. One of our aims is to get the characters in this game to pass the famous Turing Test of computer IQ. So, when you're playing our game, if you can't tell a computer character from another human player, then we're getting close to our goal!"

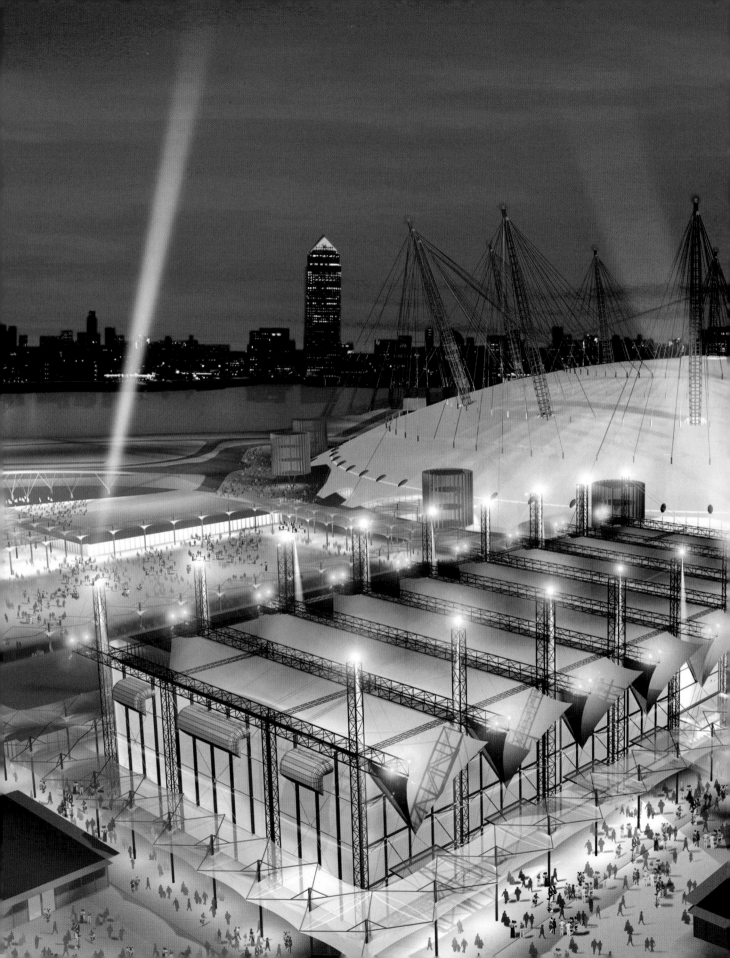

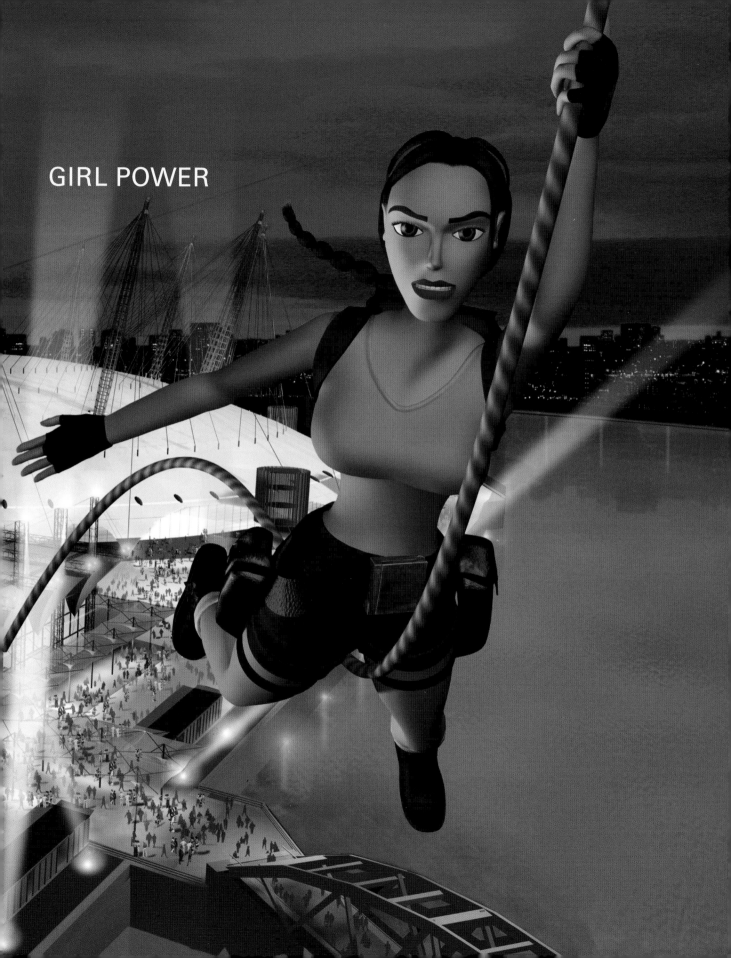

GIRL POWER

"GRRRRRL"

EMid

TOMB RAIDER I & II
VIRTUALLY THE WORLD'S MOST POPULAR BABE

EIDOS INTERACTIVE/CORE DESIGN LIMITED

The late 1990s saw the creation of two global icons that led an international movement. Both icons were made in Britain. The movement was Girl Power (or Grrrl Power if you're really tough). The first icons were the Spice Girls, and the second, perhaps even more remarkable than the first, was Lara Croft, the gun-slinging silicon heroine of the revolutionary computer game, Tomb Raider.

Computer games underwent a massive revival from the mid 1990s, when Sony's PlayStation came onto the market and PCs became a must-have domestic/consumer durable. Most of the game players were male, and mainly aged between 18 and 25. Tomb Raider surprised everyone and gave them what they wanted!

Jeremy Smith, managing director of Core Design at Eidos Interactive, recalls how it happened: "I went out to Japan to look at the new 32-bit video game consoles – Sony's PlayStation and Sega's Saturn – and realised that we had to gear up for the next generation of kit. So I took the team off-site for a brainstorming session. One of the guys came up with the idea of someone raiding tombs, which was a pretty neat idea for a computer game. So we began work on it, and the first version came back, with a male character in the lead. Not surprisingly, it all looked a bit too *Indiana Jones*. So the designer went away, came back with a female character in the lead and cut down on the tombs bit."

"We were taking a risk," he admits. "No video game had ever had a female lead, and we had doubts that young men would be comfortable adopting a female character as a role model." In the game, the player actually becomes Lara Croft and identifies closely with her predicaments, solves her problems, fights her fights. "But", Jeremy adds, "we have a company policy to let the creative teams run free, and to go with their flow. They were adamant it was going to be great."

"Timing was the key factor – timing alongside an exceptionally good game. The timing was right because as the game hit the market, girl power was emerging, *Tank Girl* had just been showing, and women were establishing themselves as powerful, successful people," recalls

Jeremy. "The guys working on the game were in touch with an emerging national mood and had no problem with the idea of a powerful female role model. The media was hungry for a new image for computer games because everyone was tired of Sega's blue hedgehog and Nintendo's Italian plumber."

A female lead would not have made Tomb Raider the success it has been unless the game itself had been top class. The key lay in the music and the visuals. "No one had seen a game quite as beautiful before," insists Jeremy. "We had developed an exceptionally clever 'room editor' which created Lara's environments in real time. This meant it was possible for the artists to view one environment, and then quickly change it by introducing a different 'wallpaper'. They had lots more control of what the game looked like and felt like. It meant they were free to create the atmosphere and feel for which the game is famous."

Tomb Raider was an overnight success. "It was tremendous. Three years on and I'm still shell-shocked. I don't believe it's something you come to terms with while you are on the crest of that wave because you are continually conscious of keeping your balance and staying up there. We knew we had it in us, and had been moderately successful, but nothing on that scale. I learnt a few lessons though. A lot of creative companies get frustrated. They might think, wow, this film, album, movie or whatever, is the best thing we've done and it just isn't selling. Move on, but don't give up. Perseverance and self-belief are the key," advises Jeremy.

"And do leave room for creativity. The Americans tend to be more formulaic, producing games to meet certain perceived marketing criteria, and I think that stifles creativity. Lara Croft would never have been developed in America because she flew in the face of market predictions. I mean who would have gone for a female role character for a macho male audience? Market research was telling us to do quite the opposite. Here in Britain, I think we are more intuitive, and Lara is a perfect example of how that instinct can pay off. Don't get me wrong, the Americans produce some great games, but I reckon we have the edge."

SEEING VOLUMES

Lon

TURNING THE PAGES
EXPERIENCE LITERARY
TREASURES

LONDON BRITISH LIBRARY

Ancient priceless documents, too delicate to handle,
locked away in climate-controlled vaults in the bowels
of museums, inaccessible to the public. Occasionally these
will be brought above ground, put under glass boxes, and
left open at one page. But the frustration is enormous
because you can't turn over!

Former art history documentary-maker Clive Izard is
project director for Turning the Pages. "This idea came
from myself with our director of public affairs, Jane Carr.
We were in Bloomsbury, in the British Museum Galleries.
We knew the new St Pancras site was opening in three
years, and wanted to find a better way to display our
precious manuscripts. We looked at video disk, we looked
at slide technology, but they didn't give us the illusion that
we wanted to create of leafing through an ancient
manuscript. We wanted to be able to scroll through it,
turn the pages, close in on illustrations and text, call up
background information and annotation. So we created
a prototype on an old Macintosh. One page used all the
available computing power, but the effect was stunning."

Clive's team then created a full-scale prototype of
Leonardo Da Vinci's sketchbook. "We found that we could
even reverse his famous 'mirror writing' to make it legible.
We realised that we had the opportunity to go deeper into
each page. During the six weeks it was on trial with the
public it was incredibly popular. Then it was a technology
race, as computer memory increased just in time for a
spectacular opening at the new library in St Pancras."

The British Library has now licensed the system, complete
with the Lindisfarne Gospels, to Northumberland County
Council and are receiving inquiries from universities,
museums and libraries around the globe. The library has
recently put the Hebrew manuscript, the Golden Hagadah,
onto the system, along with the Lutrell Psalter, a document
describing everyday life in mediaeval Lincolnshire.

As Clive explains: "This technology represents a wonderful
opportunity for the precious documents of the world to be
preserved digitally and made available to everyone – not
just the chosen few."

Welcome to Hairnet -
The UK's first Internet
training scheme for the over 50's !

ule

odel

ers

NET BENEFITS

Lon

HAIRNET
JARGON-FREE COMPUTER
COURSES FOR THE OVER 50s

LONDON HAIRNET

Hairnet founders Emma Solomon and Caroline Lambie began working together in late 1996 when they formed a web site development business.

"We are both self-taught at computing," explains Caroline, "so we know how embarrassing and demoralising it is to be in a computer-friendly environment where everyone seems to know what they're doing with their mouse, and you can't even double click!

"And we were supposed to be of a generation that's comfortable with technology," continues Emma. "We imagined how much worse that would feel if you were considered 'too old' to understand or learn about computers. Our parents were always asking us when we were going to get real jobs, because they simply didn't understand what you could do with a computer that'd take all day. It's the same with any new skill or activity, people need education and explanation."

"So, Hairnet is aimed specifically at the people which society has left 'digitally' disenfranchised," adds Caroline.

How does Hairnet work? Emma explains: "We run computing and internet classes in various venues, including people's homes, and we begin by demystifying the world of computers and building students' confidence – jargon is a dirty word! Hairnet classes contain no more than 10 people, and everyone gets their own terminal. All our trainers are over 50 themselves, and we will be expanding the scheme nation-wide by encouraging the over 50s to run their own Hairnet training licences too. We're turning the tables on the idea that IT (information technology) is a young person's thing."

"We think Hairnet is changing society's rather derogatory views on older people, and on how people of all ages are expected to learn computing. There are very few people who actually find computers intuitive, and yet we're all expected to just pick it up somehow," concludes Caroline. "So, we're aiming to make the whole process more 'people friendly', especially for the mature user."

Lon

SERIES 5
POWERFUL, MULTI-FUNCTIONAL
AND IN HAND

PSION COMPUTERS PLC

When it comes to business on the moveand living a fast-lane social life, you could say that the Filofax was crucial to the 1980s, and the Psion was indispensable in the 1990s. As the communications revolution leaps forward, what will be up-to-the-minute kit for the 2000s?

Pundits look forward to the PDA (personal digital assistant), or as a number of science fiction writers would variously have it; the slate, the comms implant, the IV (Inner Voice). You will wear this future device on your wrist, or ultimately, have it implanted in your brain and it will keep you in touch via a satellite link. A spoken command or a mere thought will give you instant access to the global network. You will be able to talk, write, dictate, record, film, remote view, send pictures, calculate, shop and research from anywhere in the world to anywhere else in the world. Almost every data source and communication media will be on tap moments after you order it up. One day you may even share your dreams.

This technology is coming and it's coming fast. Just look back at history. Any device which has improved communication has spread like wildfire; the wheel, road, train, car, mail, telegraph, phone, radio, television and the internet. Why? Because humans love to talk.

Trail-blazing the new connections and leading us into the next century, is the Psion Series 5, which has taken the convenience and connectivity of a PC computer and put it all in the palm of your hand. Martin Riddiford, a founder partner of Therefore Limited, led the Series 5 project. Previously he'd designed the ground-breaking Psion Series 3: "The brief from Psion was to make the keyboard big enough to type on quickly, and also to increase the screen size. Our target thickness was six millimetres but the best any manufacturer could offer us was eight and a half. So we worked with Psion to create our own design. It was quite a risk."

"Another risk was the touch-sensitive screen," he recalls. "We'd looked at other palm-tops and analysed their problems. By touching the screen, they tipped over. So we came up with this unique hinge that slides the keyboard towards you and then the screen hunkers down into a more stable position."

"Then we discovered another problem. It was easy to accidentally hit keyboard buttons with the rest of your hand while using the pointer-pen to navigate around the screen. We reshaped the pointer, so that people would naturally hold it nearer the top end, away from the tip and the keyboard."

PALM READER AND WRITER

Clever though this is, it does sound like standard Psion ingenuity. What is very clever though is their growing challenge to the dominance of Microsoft. "The future is mobile computing, rather than desktop PCs," says Ken McAlpine. Ken was the engineering director for the Psion Series 5 and is now part of a group looking into new business opportunities.

"Wireless information devices are becoming a massive market. The software behind the Psion Series 5 ultimately gave birth to Psion's software arm, Symbian Limited," explains Ken. "Psion remains the biggest shareholder. Nokia, Ericsson, Motorola and Matsushita have also become shareholders in preference to the Microsoft alternative. They don't want Microsoft's operating system, they want Symbian. They want to create an industry standard that isn't under Microsoft's control. And as around ninety per cent of the mobile/telecoms market is divided between these companies, they are determined to mount a challenge to Bill Gates's hegemony."

Next from Psion? The Series 7, with a full-colour screen, internet access on the move and Java. Not the "Inner Voice" yet, but certainly another step on the road to a fully portable data and communication system.

Sc SONDEK CD12
THE WORLD'S BEST
CD PLAYER

GLASGOW LINN PRODUCTS LIMITED

SOFT TOUCH

"The best CD player I've ever heard, and the one I'd want to listen to every day," (*Stereophile*, February 1999). "Immediately upon removal from its flight case, you sense greatness....This isn't just top-grade data conversion, it's a religious conversion," (*Hi-Fi News and Record Review*, July 1999). "Revolutionary rather than evolutionary," (*Ultimate Audio*, April 1999).

Just a few of the comments from a range of international hi-fi magazines about Linn's Sondek CD12 CD player. Linn's engineers claim that it's the best CD player in the world. And, it seems, the critics agree.

The five-person team at Linn, who developed this sublime machine, was led by the head of electronic design, Alan Clark. "Alastair Brown was the industrial designer, Chris McErlean looked after the software, and Keith Christie and Fraser Smith did the mechanical design. We wanted to create something special for the company's 25th anniversary. Linn's success grew off the back of its first product, the Sondek LP12, which is arguably still the best turntable in the world. We wanted to make another source component, so we went for a CD player. We wanted to make the best on the planet. And we've done it."

How? Alan explains: "Well, sound quality first. We've put a lot of research into the electronics and discovered some very important parameters in reproducing digital audio.

We've developed new circuits which eradicate the 'jitter' caused by timing anomalies in the digital audio streams. Jitter degrades the quality of the audio reproduction. But we've done some fairly extensive digital signal processing to deal with it and developed circuitry to produce pitch accurate sound." So it would seem, because the sound has been described as concert-hall quality.

The next consideration was strength of build and appearance. The first thing you notice about the Sonkek CD12 is that there are no buttons. Just touch the CD drawer to control it and a display shows you the effect you are having. But if the lack of buttons freaks you out, don't worry, it comes with a very comprehensive remote control. "The box is cut from a solid block of aluminium alloy which takes seven hours to machine," says Alan. "It gives great stability, strength and the material is one hundred per cent recyclable. The surface is machined to one micron – as smooth and precise as a CD itself. The CD drawer has no mechanical switches, just flags interrupting light beams, so there's nothing to wear out. This is built to last a lifetime."

At around £12,000 each that's what you'd expect. "You can't describe this machine," advises Alan. "Listen to it – one minute is worth a thousand words." Great! Any chance of a freebie? "No, I don't think so." Oh, well I just thought I'd ask.

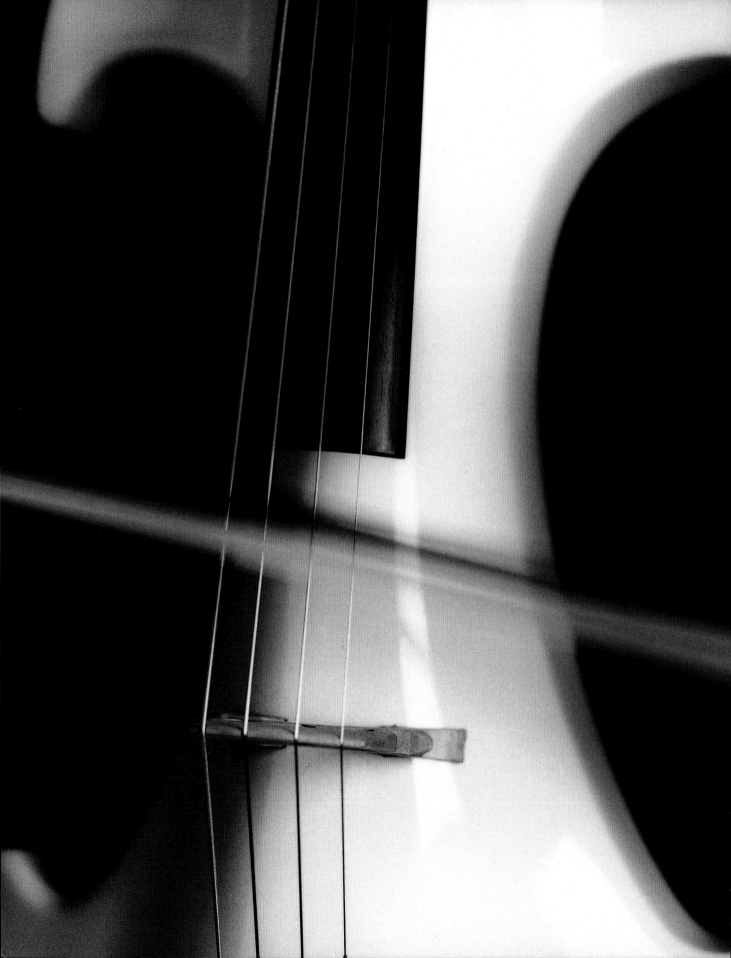

MELLOW CELLO

EMid

SLEAFORD, LINCOLNSHIRE

ELECTRIC VIOLINS, CELLOS & DOUBLE BASSES
WEATHER-PROOF INSTRUMENTS

BY BRIDGE INSTRUMENTS

As violin makers, Ceris Jones and Paul Bridgewater know that the perfect instrument with the perfect tone is a Holy Grail, something you may search for – but will probably never find. Because some days even a Stradivarius will sound dull, when the day before it had sounded as sweet as angel song. No stringed instrument is immune – travel, temperature and humidity all take their toll.

Ceris and Paul are on the cutting edge of musical instrument design, and their new instruments proclaim the lofty virtue of being almost immune to environmental conditions. Recently, BBC's *Tomorrow's World* tested traditional wooden instruments against Bridge's instruments in a tropical pavilion in London's Kew Gardens. In the hot, humid atmosphere, the traditional instruments began wailing like tortured cats as the structure of the instruments became unstable. But the Bridge instruments held their tone. How? By using aviation technology.

"We used to make wooden violins, but now we rarely do," recalls Ceris Jones. "The big difference with our instruments is the material. We are the first makers to use Kevlar and carbon fibre, which are far more stable than wood, much stronger, very light, and resistant to temperature change." Kelvar and carbon fibre are used to build jet fighter aircraft where strength, temperature resistance and lightness are essential.

"Our instruments are designed to be electrically amplified, but we don't make the bodies solid, for instance, like an electric guitar. Our experience is that there has to be air resonance to get a truly good tone. So the bodies are hollow, like a traditional wooden instrument, and the air resonance within the body is 'picked up' by electronic sensors. Each instrument has a frequency-dedicated PCB (printed circuit board) which is designed to suit individual tonality," explains Ceris.

"The real pleasure of this business is watching great players use your instrument. Jon Sevink of the Levellers uses our violin. Stephan Grappeli's prodigy and protégé, the top French jazz violinist Didier Lockwood, uses a Bridge violin, and recently played with top American soft jazz player Patti Weiss – both on Bridge instruments.

NE

NOTRON
INSTRUMENT FOR SCULPTING
ELECTRONIC SOUNDS

LATRONIC LIMITED

"It's a step-time sequencer. There's nothing like it....It's essentially a midi instrument. All very touchy feely." Yes Mr Inventor, but what is it?

Notron is a new electronic instrument and tool that is causing musicians, DJs and muso-hacks to bow down before it. Björk has had one especially commissioned (featuring an add-on, remote "electronic harp" device) and Andy Hughes of The Orb loves his so much, he calls it a "cosmic cow-pat".

Notron allows professional and non-professional musicians to manipulate sound patterns in a new, easier and more intuitive way. It is able to trigger sounds from a PC computer or a sampling machine, to create new tunes and musical textures in real time. You can use Notron to quickly develop melodies, riffs, chord sequences, drum parts and sample loops.

Inventor, Gerard Campbell: "Imagine you are playing an E-chord on a classical guitar. There are lots of ways of doing that. Each different E position gives a different texture to the chord. Then you can pick it – softly, or harshly. You can strum it all kinds of ways from very, very lightly to very dramatically. This kind of control and sound variation is really difficult to emulate on an electronic keyboard. The Notron lets you do this, giving you access to musical subtleties normally only practised by virtuosos."

Gerard is a noise-maker from a "grebo" rock band background, but, he explains, "...an extremely unsuccessful one. I've always loved manipulating sound, and have used computers to make music but got bored with the time it took. You'd play something on the keyboard, record it in the computer, play it back, pull down a menu, cut and paste, edit it, re-record it....It took so long to get anywhere. Whereas on a normal musical instrument, once you have an idea, you can nip about all over the place. But computers are very good at making some amazing sounds. I wanted the best of both worlds, really."

"One day I woke up with this idea," recalls Gerard. "What if you had something like a drum machine to trigger electronic music sounds, but you also had knobs and dials to alter the characteristics of those sounds, instead of endless computer-screen menus and a mouse, then hey

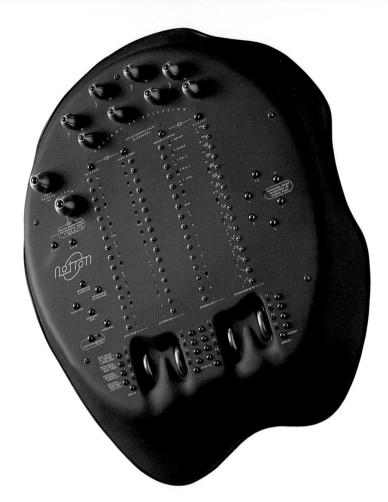

presto, you'd have more real-time control. I told myself that I had to do something with this, and promptly didn't."

"At that time I would often go gambling to play system roulette. One night I lost £50 at a casino and was in a bad mood, tramping home because I'd lost my bus money. To take my mind off it, I decided to work on the idea. I ripped the back off a drum machine and soldered a couple of wires into a midi drum pad, which you usually hit with sticks. I programmed some triggers into the drum machine and set it running. I couldn't believe how musical it sounded. I called a friend and asked him to tell me whether I'd gone mad or did it sound good? He said it sounded good."

"So I built up a spec' by adding more features. I like fiddling with concepts through matching up electronics with rule-driven behaviour, but getting something this complex built was way beyond anything I'd managed to do previously. So I pulled out the *Yellow Pages*, looked up the first electronics and software company within cycling distance, sent them a fax and asked if they could build this thing for me," explains Gerard. "They said, yes, come and

talk. They specialised in control systems for oil rigs and factories. But it's all about writing code to control variables. When they started talking money, I said, hold on, I haven't got any, why don't we form a partnership. So we did."

The result has been a tremendous success in the music business. Andy Hughes of The Orb waxed lyrical about the Notron in an interview with *The Independent*: "The Notron is quick. I have had a whole studio running off this little cosmic cow-pat. I like stuff that's tactile like the Notron. It's like a lot of old analogue keyboards which you can actually grab hold of. With the Notron, it's right there and easy to use. You can actually take chunks of the song and move it around, like a word processor."

Being compared to a word processor, that's serious. And we all know how influential that little device has been.

(EXTRACT REPRINTED BY KIND PERMISSION OF JENNIFER RODGER AT *THE INDEPENDENT*)

ANTI-BLUR DEVICE

E

AUTO-MONTAGE
CREATING PERFECTLY
FOCUSED CLOSE-UPS

CAMBRIDGE SYNCROSCOPY (A DIVISION
OF SYNOPTICS LIMITED)

Imagine that you want to photograph something small, really small – the face of a baby spider for instance. You'll immediately find that as you zoom, your optics won't be able to keep it all in focus. You'll home in on the upper mandible and the eyes will go all fuzzy, focus on the eyes, and the mouth parts will become vague. It's the perennial problem with close-ups because it's very difficult to create an optic that gives you sharp focus across the entire object. That's why books on entomology are mainly illustrated with pencil drawings. But this problem is familiar to all photographers – it's called depth of field.

Accurate three-dimensional, fully-focused colour images are essential for a wide range of applications, from materials analysis to microbiology. Until April 1997 it was impossible to produce such images of small objects. You could use a laser technique called Confocal Microscopy, but this was (and remains) expensive, is only appropriate for a small proportion of applications, and generally produces black and white images.

What if you could come up with a system that was ninety per cent cheaper, gave you colour images and could be used for thousands more applications? Dr Phil Atkin,

founder and managing director of Synoptics, had his Eureka moment following a visit to the company by staff from the Natural History Museum.

"The museum is busy cataloguing rain forest species before man wipes them out. They wanted us to develop a manual system of focusing on an object at one level, drawing around the sharp image, focusing on the next level, drawing round that, and so on through about 30 levels so that you gradually paste together the in-focus regions. They were very happy with the results, despite the amount of labour, and soon other entomology departments around the world were buying the system. But I couldn't help thinking that the Natural History Museum wanted something more – an automatic way of putting the image together. I kept suggesting it until finally they said, do it! So I did."

How do you create an image with a depth of field that exceeds the optics with which you are photographing it? Indeed, it sounds difficult, like asking how can Dr Who's Tardis be bigger inside than it is outside? "But really the principle is simple, it's a wonder no one had thought of it before," explains Dr Atkin. "What we do is digitally

photograph each level of the object. Say, first the top, then a bit lower, and then a bit lower, until we have around 30 images. Then a computer brings all the images together to create an entire fully-focused image. The trick, of course, lies in getting the computer to bring them together."

"Using our own imaging software, I asked the computer, what's the best sharpness we've seen in region A from these 30 images?" recalls Dr Atkin. "It identified the best image for that region and then combined it with the best images from every other region. Within half an hour I had a good image and two weeks later I had a saleable product. The competition still hasn't worked out exactly how we do it!"

Sales manager Bob Town says that Auto-Montage has no effective competitors, and so far they've sold over 450 licences. "There really is no limit," explains Bob. "We are photographing features which are a millionth of a metre across. Now we're using the system for many other applications, to visualise, photograph and measure all kinds of tiny objects that just couldn't be seen before."

FASTER THAN A
VERY FAST THING

E **IMACON 468**
ULTRA HIGH-SPEED CAMERA
IT CAPTURES MOVEMENT

TRING, HERTFORDSHIRE DRS HADLAND LIMITED

The Imacon 468 Ultra High-speed Camera is capable of taking 100 million pictures a second. Is that a mind-boggling statistic, or what?

But just exactly what are you going to take pictures of at the rate of 100,000,000 frames a second? Rather than "What the Butler saw", it's more like: "What the Supreme Being spotted with His all-seeing eye when he was really concentrating."

The supremely level-headed Joseph Honour, project manager for the Imacon 468: "There's a wide range of uses because we create systems and sometimes we're not sure how they work, or whether they might work better with a little adjustment. Let's say you're checking the spark jumping the gap of a spark plug. It takes a full 10 nanoseconds to get from one terminal to the other. We can film that. We can film bullets deforming on impact with steel, we can record petrol leaping from a fuel injector, we can trace the sudden development of a crack in materials under extreme pressure." There's all sorts of things that you can do with an Imacon 468.

We're frightened to ask this, but how on Earth does the thing work? "The recording media is a CCD chip," explains Joseph. "This isn't a particularly fast sensor, but we've

married it to an intensifier which can be turned on and off very fast. This on-and-off 'gating' acts like a shutter."

"There are eight of these chips in the camera, and they sit behind a beam splitter. What happens is the light from the object you are taking pictures of comes through the main lens and into a prism which splits it into eight beams, which then fall on the eight chips. The chips are controlled by a processor that adjusts their sensitivity, time between frames and exposure time. So you can take eight consecutive images in a tiny fraction of a second, with each chip recording an image a few microseconds apart," says Joseph.

"Another big plus of the system is that the user can analyse what the camera sees. So if it's examining a spreading crack in a new material, you can tell how quickly the crack has spread, how far, what direction, where the main stress was, etc. This is very useful information if you are developing composite materials. Also, the Imacon 468 comes in a compact unit, competitively priced and easy to use."

PROBING FOR ANSWERS

SW

SP600M ANALOGUE PROBE
DLC ANALYSER
UV RAMAN MICROSCOPE
HS10 LASER SCALE SYSTEM
HIGH-PERFORMANCE TOOLS FOR THE FUTURE
RENISHAW PLC

Renishaw is probably the UK's most innovative maker of high-tech measuring systems. It is on the cutting edge of its industry and well known for being both a pioneer and field leader. Hence the fact that the company has so many Millennium Product awards – a total of nine when this book went to press.

The Analogue Probe is an ingenious device that enables copies of three-dimensional objects to be made which can then be translated into models or moulds. Before this technology arrived, designers would use some form of pantograph to make a copy of an object. But Renishaw has made the process much easier.

Imagine that you are trying to reproduce a Coke bottle. The Analogue Probe assesses the surface and then drives over it, taking measurements, recording the curves, dips and rises of the glass flutes, the narrowing of the neck, and the bulge of the rim. It sends all this detail to a computer. The computer programme creates an image full of technical data, which can be re-sized at the press of a button. You can reverse the image, so you have a negative, which is very useful if you're making a mould. Or you can shrink the original if you want to make a plug around which the bottle could be moulded. The computer sends the information to a cutting machine, and the Coke bottle,

or its mould, is reproduced there and then, out of a suitable material.

Michael Sykes, Renishaw's public relations officer: "What makes this far better than its competitors is its faster speed, greater accuracy and lower contact force. Models for manufacture are often sculpted in wax. There is a danger that the scanning process will deform the original and produce poor copies. Our technology is particularly popular in Japan, where they often prefer to work with a solid model than with the three-dimensional images generated by CAD/CAM technology (computer aided design/computer aided manufacture). The product is selling extremely well and is popular because it can be attached to existing machinery.

Other Renishaw products include the DLC Analyser, which enables computer hard drive disks to store larger amounts of information. Michael: "This measures the thickness of the diamond-like coatings used on the disks to lay down tracks for storing data. It's incredibly accurate, which means manufacturers can be sure of the quality of the disks and so pack more information onto them. Twenty megabytes used to be an impressive size for a hard disk. Now, upwards of 20 gigabytes is the norm. And it's no bigger than its 20 megabyte ancestor."

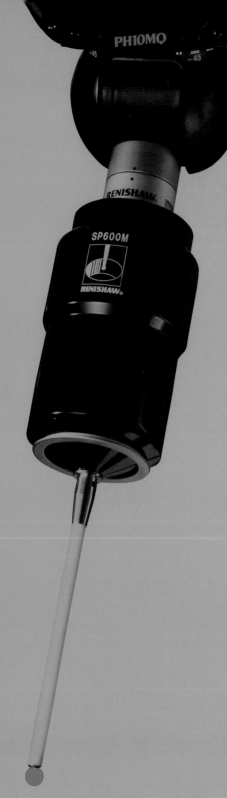

The UV Raman Microscope is used in forensic science for highly detailed spectral analysis. It's been used for detecting Semtex and can also analyse the dispersion of a drug within a tablet.

The HS10 Laser Scale System is used in aircraft manufacturing on large profiling machines. It dramatically increases the capability of large machines to hold tighter tolerances and improve surface finish in "shop floor" conditions. In the airline industry, for instance, to achieve a similar standard would necessitate an aircraft being built in a laboratory. And that's an expensive operation! "Some planes, such as Boeings for example, are built in locations with considerable temperature variations, which can greatly affect accurate measurement," explains Michael. "But the HS10's laser measuring scale uses a patented environmental sensor that compensates for changes in humidity and temperature."

SW

SILICON GYROSCOPE
A LOW-COST GYROSCOPE WITH NO MOVING PARTS

PLYMOUTH, DEVON BAE

Have you ever wondered how on Earth a gyroscope keeps a plane the right way up or tells a rocket which way to go in space? Well, now there's a gyroscope with no moving parts. Sounds like a contradiction in terms.

In the mid 1990s it began to dawn on people at BAe that classic gyroscope technology was becoming hopelessly outdated. But they had spotted a potentially massive new market for an inexpensive, rugged, solid state gyroscope for car braking systems that would increase road safety. They also discovered that their competitors were thinking about making such gyroscopes out of quartz. So BAe decided to go for the far riskier option and create the world's first silicon gyroscope. The company reorganised, set up a unit dedicated to developing and producing the new product, and as a consequence, changed forever.

Colin Fancourt, head of business for solid state sensors at BAe: "We'd been asked to look at developing a rugged military gyroscope that would go inside a mortar and be able to withstand the launch shock. That was back in 1992. It got us thinking about an alternative to rotating gyroscopes, because they simply cannot withstand the shock of a projectile launching. We started looking into creating a solid state gyroscope, and what it's possible commercial applications would be. We reached the conclusion that the market for classical gyros was running into the buffers – that sooner or later demand would die

SUPER SENSITIVE

ACTUAL SIZE

because the market wanted smaller, less expensive, more robust devices that required less power. Once we realised this, it became an incentive to do something about it."

"We looked more closely at the possibilities of solid state and created a two centimetre ceramic cylinder, which worked very well as a gyroscope and still sells today. But we needed something cheaper. Quartz technology was already proven in the time-keeping industry but wasn't tough enough for the job. The specs' for an in-car gyroscope require an ability to handle massive temperature variation, from the Arctic to Death Valley, plus it has to withstand engine vibration and a car's debilitating electrical environment and powerful shocks from impacts."

"The truth is that we couldn't be sure if we would be able to machine silicon to the required dimensions," admits Colin. "Micromachining technology for silicon was in its infancy, so, the silicon route was high risk. From the benefit of hindsight, the choice is easy – silicon is the better technology, but at the time, if you'd been a betting man, you'd have put your money on quartz because it was a proven technology."

How does the silicon gyroscope work? "This explanation will probably horrify scientists," continues Colin, "but imagine a round rubber band lying on a table. If you push the two opposite sides in with your finger, the top

and bottom bulge out. You've got four related movements, up, down, left and right. That's how rings and cylinders react to some stimuli. By using electricity you can make a silicon ring vibrate in a similar manner. The resulting vibration on the silicon ring is changed when the device rotates and so you can work out where the object is in relation to everything else. In fact, you can detect its orientation in relation to the Earth, or, more accurately to 'inertial space'. Put a silicon gyroscope in a still object and it will actually indicate the movement of Earth through space. That's what's know as the 'Coriolis effect'."

"Basically, what the in-car gyroscope does is detect whether the car is moving as the driver wants. If there is a difference between the way the steering wheel has been turned and the direction the car is turning (i.e. if the car is about to enter a skid), the system causes brakes to be applied to the individual wheels to bring the car back under control. It happens so fast that you can't detect it. It spots your skid and gets you out of it before you realise that there's a problem. So it makes the car much safer, much more stable."

"Currently we are looking at other applications, including one for the computer industry. A three-dimensional mouse. Imagine, a mouse-sized scanner which you can just run all over a three-dimensional object and then download the information directly into your computer!"

POLES APART

SW

SCIMAT 700/30 & 700/35
NEW SEPARATOR FOR
RECHARGEABLE BATTERIES

SWINDON, WILTSHIRE SCIMAT LIMITED

Battery technology has been a major stumbling block for miniaturisation. But with the mobile communications market going through the roof, the economic incentive is there to create more powerful energy units; ones that last longer, are quickly recharged and are smaller, lighter and much greener.

At the forefront of battery technology is Scimat. John Cook, technical support manager: "Take a look at the battery on your mobile phone. Chances are that it's a NiMh battery which contains our product."

"Up to a few years ago, such batteries were made of nickel cadmium (NiCad). But there were problems. For starters, cadmium is one of the most toxic metals in the world. Secondly, their capacity was low and they had to be recharged often. Then the metal hydride battery began to come to the fore. But though they are better and last

longer before needing to be recharged, there was one problem – they used the old nickel cadmium separator."

Nickel cadmium what? Time for a quick lesson in batteries and how they work: "A battery has three basic bits," explains John. "The first bit is made up of the two electrodes, one positive, the other negative. Then there's the electrolyte, which reacts with the electrodes to cause an exchange of electrons to generate electricity. The electrolyte in hydride batteries is typically alkaline, such as potassium hydroxide and water. The third bit is the separator, keeping the opposite poles apart, but absorbing enough electrolyte to allow the exchange of electrons. The separator has proved to be critical in improving hydride battery performance."

"In the NiCad days we used a nylon separator," recalls John. "But that doesn't work so well in the hydride batteries, because it chemically degrades, causing the battery to loose charge rapidly even when it's not being used. So we started experimenting with polypropylene. We subjected it to an ultraviolet grafting treatment which made the material hydrophilic. This helped it to absorb the electrolyte more thoroughly and immediately improved the recharging capabilities. Plus, a further significant advantage is that batteries no longer loose charge when not in use."

"We've patented it, of course, and are now the world's biggest suppliers of separators for hydride batteries," says John. "And the NiMh separator breakthrough has important environmental implications. Hydride batteries are much greener than their cadmium forebears and promise to be ideal for the electric vehicle market."

CURE FOR THE
UNCOMMON COLD

"THE PUBLICITY GENERATED BY MILLENNIUM PRODUCTS HAS BEEN QUITE INCREDIBLE. WE RECKON WE'VE HAD OVER £500,000 WORTH OF FREE ADVERTISING THROUGH GAINING MILLENNIUM PRODUCT STATUS. AND THE MESSAGE HAS SPREAD WIDE. WE'LL BE SITTING IN A HOTEL ROOM IN ZURICH LEAFING THOUGH A MAGAZINE AND FIND OURSELVES READING ABOUT GORIX. OUR BIGGEST PROBLEM IS COPING WITH THE NUMBER OF INQUIRIES WE'VE HAD." JOHN GORDON, DIRECTOR

NW

SOUTHPORT, LANCASHIRE

GORIX
ELECTRO-CONDUCTIVE TEXTILE
FOR HEATING AND BONDING

GORIX LIMITED

Gorix is the first material which, when draped, will still conduct electricity uniformly throughout its fibres. The implications of this breakthrough seemed obvious to its inventors, Robert Rix and John Gordon. "We thought – wow – we could use this for heated clothing, for heated car seats, even heated carpets," recalls John.

But these uses have become peripheral in the light of the dramatic applications for which Gorix is now being tested. "There is a race on in the passenger aircraft industry to build a plane entirely out of composite materials," says John. "The initial cost is high, but the pay-off comes in the dramatic reduction in maintenance bills. At the moment a leading aircraft manufacturer is trying to build a wing entirely out of carbon composites but this is extremely difficult. How do you bond the top and bottom layer? If you use a massive oven it creates all manner of stresses and strains. The answer lies with Gorix, which itself is made of carbon. Gorix material is being set into

a wing-shaped plate of glue that will be put between the two halves and heated. Because Gorix spreads the heat uniformly there will be no hot and cold spots, producing a perfect bond."

There is also huge interest in Gorix from health product manufacturers. A large German company wants to use Gorix for heated wound dressings. The carbon structure also works to absorb odour and wound debris, and it is currently being applied to broken bones to help them heal.

"When we started we were terribly naive, running up so many blind alleys," explains John. "But now we're learning to be businessmen. We've focused on two areas, composite materials and medical applications, and let the heated diving suits, motorcycle jackets and carpets look after themselves through licences. It's been a roller-coaster ride – but what a ride."

CLASS BALANCING ACT

E **STAIRMATE**
COMPACT PLATFORM
PROMOTES LADDER SAFETY

SANDY, BEDFORDSHIRE EASI-DEC ACCESS SYSTEMS LIMITED

Could your stairwell do with a lick of paint? The chances
are it either does, or will soon enough. So how do you
intend to go about it? Balance a ladder on the stairs and
risk your life? Tie a plank onto the banister and get your
partner to hold it steady while you stand on it, dripping
paintbrush in hand, wobbling precariously? Tie the paint
roller to a long pole and splatter paint all over the
woodwork? Hire a builder's tower, which takes ages to
assemble and blocks access up the stairs for the two
weeks it takes you to get around to doing the job? It was
out of scenarios like these that Stairmate was born.

City of London fireman and black cab driver John
Sandham called up his fire-fighting colleague Stan Lewis
and asked him if he had any equipment that he could
borrow as he was painting his stairwell. "On 25 March
1995, John popped around to my place and saw the
platform I'd made for the job," recalls Stan Lewis. "He
said, that's brilliant, you ought to patent it! You've got to
do something with that....So we began to discuss how it
could be better. By lunch time the next day, with the snow
falling, we had our first prototype, a folding model that
didn't quite fold flat enough."

So began the two firemen's quest to make a device which
would fold flat, be cheap to mass produce, quick to install

and yet would hold a ladder steady when mounted on the stairs. They took bits from car jacks, work benches and folding chairs, and finally produced a model which they felt confident enough to show to manufacturers. "While demonstrating it to a likely firm," recalls Stan, "one person looked particularly doubtful and I heard him say to his boss, well it's not doing what I expected it to do. I felt pretty bad, until I realised that he had presumed it would tip over when the ladder was added."

They signed a deal, but due to a take-over were dropped. "We knew the invention was good, so we kept on going," says Stan. "We had spent £15,000 and counting, plus £2,500 for what may have been our final shot, the 1997 International Inventions Fair at London's Barbican Centre. Then we had an approach from Easi-Dec, sold them a licencing deal, and now we receive royalties on sales."

The special products manager at Easi-Dec is Julian Sproll: "It is such an ingenious and innovative product. We saw that it could fill a niche in the market because there simply isn't a comparable product, nothing gives such easy access to a stairwell. It takes less than 30 seconds to get it ready. Response in the UK has been good, with ToolBank and Brewer's stocking it, but it's moving even more quickly in Holland."

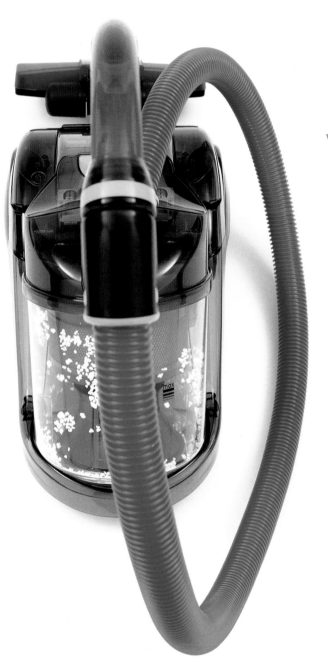

VACUUM ACT

SW

DYSON DUAL CYCLONE DC02
BAGLESS, STAIR-CLIMBING
VACUUM CLEANER

DYSON APPLIANCES LIMITED

"If there were a better kind of vacuum cleaner, someone would have invented it." James Dyson received this reaction to his design for a bagless vacuum cleaner for many, many years. But he didn't give up. And refusing to give up has been the hallmark of the phenomenal Dyson success story.

"The Dual Cyclone was an idea born and nurtured in the cradle of frustration," explains James. It began one day when I was doing the vacuum cleaning. I was a few minutes into the job when I realised that the machine wasn't sucking any more. So I emptied the bag. Two minutes later I was having the same problem. I pulled the bag out to have a look. It was empty except for a layer of fine dust."

A vacuum cleaner works by sucking air through a bag. Dust and particles are dragged in as air is drawn through the bag's pores by the fan. The problem is that it doesn't take long for those pores to become blocked. Then the suction begins to drop off.

"At the time I was producing the Ballbarrow – an all-terrain wheelbarrow with a ball for a front wheel," recalls James. "We had just installed a powder-coating plant to paint the frames. The stray paint was captured by a giant vacuum cleaner containing a filter that needed hourly cleaning."

"I spoke to the suppliers about the problem. They told me that big operators used a 'cyclone', to separate the paint from the air. It works by spinning the paint-filled air until all the solids fly out to the side and then drop down into a collection bucket. So we built one of our own in the factory. The excess spray was sucked into a funnel, flew up the ducting, flowed round the walls at the top of the 'cyclone' and spiralled down through an inverted cone. All the solids collected at the bottom. Then I thought, 'bagless vacuum cleaner'."

James rushed home and made a cardboard model of the cyclone and attached it to his vacuum cleaner. Eureka. A vacuum cleaner that didn't lose suction. So began a 15-year journey through 5,000 prototypes. Twelve years into the project he was £4,000,000 down on the idea, and getting nothing but rejections. "Then an unusual bank manager, from Lloyds, came behind the idea and helped me secure a £600,000 loan," remembers James.

"I took the idea to most of my current competitors but they all rejected it. They were more concerned about arguing that their product was quite good enough, thank you. They weren't interested in a new approach. I was saved from bankruptcy, not by an entrepreneurial British company, but by a Japanese firm which approached me about the idea and we quickly signed a licensing agreement."

Dyson is now the brand leader with over fifty per cent of the UK floorcare market. He sells over 92,000 units a month. These days James employs 1,400 people, around 350 of whom are design engineers working to come up with new product designs. That's a giant design office for any manufacturer to support in-house. James has his reasons; "I'm not going to make the same mistake my competitors did by ignoring new ideas and new technology."

SW

STONEHOUSE, GLOUCESTERSHIRE

POWERDRIVE
STEERABLE ROTARY
DRILLING SYSTEM

CAMCO INTERNATIONAL (UK) LIMITED

Oil is a non-renewable resource and one day it will run out. The sooner the better, say some environmentalists, because oil products have done untold damage to the environment not least through the massive infrastructure of multiple rigs and pipelines that mark the presence of oil fields around the world. Pragmatists will argue that while developing alternative energy sources is essential, in the short term we're stuck with oil as a necessary resource, so we'd better improve the extraction process and fast.

John Clegg, engineering manufacturing manager for Camco: "If we can make what's in the ground last longer, then we won't have to keep on opening up new fields. And if we can exploit a field with less rigs, then that will correspondingly decrease the effect on the environment."

Imagine, for a moment, that an oil field is like a thin sheet of black material sandwiched between rocks thousands

LATERAL SINKING

of feet down in the Earth's crust. Now imagine drilling for oil and hitting it. You have effectively perforated the sheet with a pin. It will leak oil for a while which will be piped away, but soon the area around the pin-prick will become empty. So you have to drill another oil well. And another, and another. And by the end of it all, you'll only have come away with one-third of the resource.

But now the drills are changing and, thanks partly to clever developments by Camco, they can drill horizontally and around corners. "It means that we will be able to extract another third of the oil from a field which was previously thought to be totally tapped," explains John.

"The PowerDrive is the first drillhead to permit a friction-free rotation of the entire drill assembly. And, the steel pipe following the drillhead is sufficiently flexible to go round wide corners. This effectively allows the drill to be steered around a curve and horizontally away from the rig. It means it can search for oil laterally through the thickness of the reservoir, and therefore take up much more."

BP recently used the system to drill a record 10 km lateral borehole under Poole Harbour in Dorset, extracting Channel Oil deposits. At its peak it was one of the largest oil-producing fields in the UK, but by using horizontal drilling, there was minimal environmental impact. "With fewer rigs, there's less use of materials, fewer chances of spillages and less clearing up afterwards. And, if off-shore reserves can be tapped remotely from the coast, it's less expensive too."

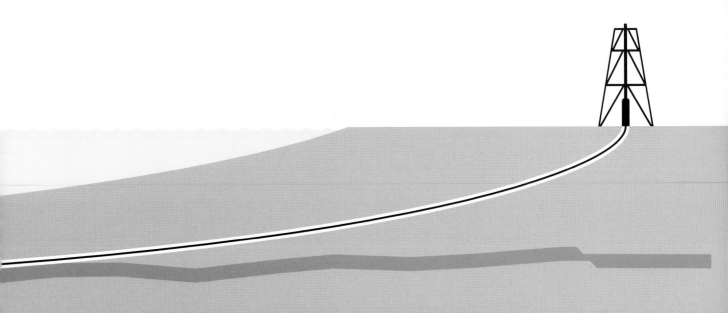

WMid

THREE DIMENSIONAL MAPPING
UTILITIES INDICATOR SAVES
ON ROAD-WORKS

TIPTON, WEST MIDLANDS AM SURVEYS LIMITED

When you're stuck in yet another traffic jam, chances
are it's due to roadworks because utilities companies
frequently need to dig up roads to repair underground
equipment and lay pipes and cables. It may be necessary
– just one of those modern-day inconveniences and we
love our cable channels – but that's no consolation when
the traffic's crawling.

Now, however, thanks to a unique system pioneered by
AM Surveys Limited (which is a joint venture between
Midlands Electricity and Aegis Surveys), there may be an
end to traffic mayhew in sight. Using specialised three-
dimensional mapping methods along with directional
drilling techniques, the system can lay underground cables
without digging up the road. Another plus is that it cuts
out the chances of accidently hitting and damaging
existing buried utilities.

VISIONS UNDERGROUND

The method utilises horizontal drilling – sending a drillhead under the ground to make way for semi-flexible pipes and/or cables that are then fed into the borehole. This isn't a new idea but the technological development has been hampered because it's all to easy for a drillhead to plough straight through another cable, sewer or water main. And, of course, the problem is even more pronounced in dense urban environments.

AM Survey's director of tracing, Ian Oliver: "Three Dimensional Mapping creates underground maps in three dimensions," explains Ian. "It combines traditional electro-magnetic location (the type used in metal detectors) with a ground-probing radar so as to locate the exact position of pipes and cables. When an operator wants to run a cable from A to B, we survey the route, put the results into specialised software and generate the information in a three-dimensional format, or if preferred, in two dimensions with depth readings. And that gives the operator the safest-possible route."

Electricity companies using the new system for cable laying are reporting savings of around forty per cent. While the system doesn't promise a cone-free future, it could make for less hold-ups and that can't be bad.

TRAIN-LINK-EUROPE

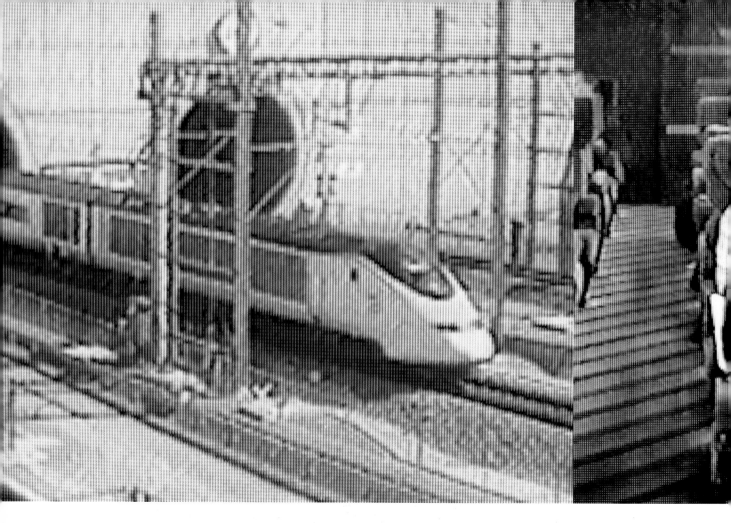

Lon

EUROSTAR
CONNECTIVITY &
COMFORT BY RAIL

Do you feel that Europe and Britain have moved closer together? Well, if you looked at a map you'd see nothing's changed. But, if you went down to London's Waterloo International Station you may feel otherwise.

Thanks to Eurostar, which links London via the Channel Tunnel to Paris (in just three hours) and Brussels (in just two hours and 40 minutes), it's now so easy for us Britons to nip over and meet our continental neighbours. (It's even faster if you travel from the intermediate terminal at Ashford in Kent.) And for that, Eurostar has been awarded Millennium Product status on two counts; because of its unique contribution to transport, economic and cultural links between the UK and mainland Europe, and, because of the striking design of its trains.

Michael Rodber and his team at Jones Garrard designed the distinctive nose cone of the train: "The design was

commissioned through a competition with a purposefully vague brief . We approached it with three main ideas – that the nose should symbolise Britain's linkage to Europe, that it was a flagship for three separate railway companies and that it must be a 'euro brand'."

"So we made as radical a shape as possible. Totally unique, streamlined, but different. We took fish as our inspiration, as it was to travel under the sea. When we presented it at the competition people looked shocked," recalls Michael. "Am I proud of it ? Yes! Train design is like architecture with the added dimension that the building moves. You can make quite a statement with a train."

Eurostar has for ever revolutionised cross-channel travel. Hamish Taylor, Eurostar Group's executive officer: "Many more people are now able to travel thanks to the ease of access which Eurostar provides. Our research indicates that five-times as many people in London and the South East have visited Paris than did before the new service. And in return Eurostar brings millions of visitors to the UK each year. Moreover, the image of the train has become a powerful visual symbol of Britain's links with Europe."

Ease of use has been crucial to Eurostar's success. As travellers will testify, it's a hassle-free experience, from check-in to arrival, not least because Eurostar has an excellent record for punctuality and reliability. With its uninterrupted travel time, it's a favourite with both families and business people who appreciate the opportunity to work while travelling city centre to city centre.

In addition to the two European capitals, Eurostar is doing increased business to the intermediate city of Lille, on the direct service to Disneyland Paris® and, during the ski season, to the French Alps.

HOLY GIANT CRADLES OF ADVANCED
COMPOSITE MATERIAL, BATMAN

SE

BECKENHAM, KENT MAUNSELL LIMITED

CARETAKER BRIDGE ENCLOSURE SYSTEM
LOW-MAINTENANCE CLADDING SAVES ON PAINT

A bridge too far gone. In fact, several bridges too far gone. Some of the UK's massively impressive motorway viaducts that leap deep valleys and span wide rivers are beginning to crumble, despite their 120-year design lives. Indeed, some of the less lovely bridges are also deteriorating, which you might say is no bad thing. But they still have to be repaired because the cost of replacing them is unthinkably high.

The answer lies in prevention, decay arrest and repair; which could also be a prohibitively expensive programme. But Maunsell Limited, working with the government's Transport Research Laboratories (TRL), has come up with an idea so simple and brilliant that it's set to change the look of road bridges across the UK and around the world.

Maunsell technical director Richard Irvine: "The government's been seriously worried about this problem for over 20 years. TRL have been looking at a range of possible solutions. The one that showed the most promise involved them cladding a section of a bridge in wooden boards. It showed that degradation of the bridge was far slower behind the wood."

Similar problems were happening to the Tees Viaduct on the A19 in the early 1980s. "That bridge was 15 years old and in a bad state. The corrosion was phenomenal. The mobile access gantry had decayed so much that it had effectively welded itself onto the structure. No one could get at the bridge to do anything. So we said to TRL, let us take your concept of enclosure as a preventative further."

"We started work on making enclosures out of advanced composite materials, which are incredibly tough and

durable," recalls Richard. "Our aim was to create a system that was a bit like Lego – a collection of components that connect together to form different configurations. We wanted to apply the system from bridge to bridge, so it needed to be universal and flexible."

"We enclosed the underside of the Tees Viaduct, creating a 'soffit', or flat floor, hanging beneath the bridge. The floor was suspended on hangers and, by its very nature, allows maintenance people permanent, protected access," explains Richard. "Government tests later showed that degradation of the bridge's steelwork had been reduced by ninety-five per cent thanks to the enclosure. It meant there was so little decay that there was no need to paint the steelwork any more. Maintenance can happen without risk to inspectors and engineers and without disrupting traffic. Problem solved."

"Recently we've refined the system for the new Severn Crossing (between South Gloucestershire and Wales). The Royal Fine Art Commission took part, and suggested we introduced curves into the structure to create aesthetic appeal. So we designed curved side-panels which interlock with the floor section. It looks great. Now we have a system that not only protects bridges, but can actually enhance the appearance of some of those dreadful eye-sores that local residents have been complaining about for years."

The Bridge Enclosure system has been licensed in the USA, where it's currently undergoing trials.

SUPER BRIDGE

SE

CROYDON, SURREY

LANTAU LINK
A BRIDGE FOR ALL SEASONS

MOTT MACDONALD

In 1940 there was an incident which shocked engineers around the world. The Tacoma Narrows suspension bridge in Washington, USA, began to vibrate in sympathy with a wind blowing down the valley. The "damping" on the bridge was inadequate and the vibration made the bridge twist and dance before it finally fell apart.

The Tacoma incident has been an object lesson ever since. The destruction has been analysed and engineers are as confident as they can be that they'll never let it happen again. But what happens when you receive a commission to build a bridge in a typhoon region? How do you build a typhoon-proof bridge?

Mott MacDonald's Jeff Young led the Lantau Link design team in the UK and was chief resident engineer on site in Hong Kong. The mission was to provide a transport link to the new airport which is built on a man-made island. "It was a challenge, certainly, but then engineers like challenges. The major part of the link consists of the Tsing Ma suspension bridge, which carries a 135 km per hour train over a span of nearly 1.4 km – longer than ever before. At that sort of length, we even had to take into account the curvature of the Earth. And we had to design it so that it would not vibrate itself to destruction in winds of up to 300 km per hour."

"We made the bridge a box section, so that the train would run through an aerodynamically shaped box," explains Jeff. "To further reduce the effects of wind power, we introduced vents into the box section, slots in the upper and lower section that allows wind to pass through and works to increase the bridge's stability and dampen vibration. The bridge is a six-lane double-decker, with the train running under the road carriageway. When the wind turns nasty, high-sided lorries on the upper carriageway move down to the lower deck. There they run on a road specially built beside the rail track which is protected by the stream-lined edges of the deck. In full typhoon conditions the bridge would remain operational. Whether any cars could make it through the weather to get onto the bridge is another matter. But you'd be safe on the bridge once you got there."

"We received the commission in 1989 and had to complete by 1997 or the airport would open but no one would be able to travel further than the arrivals lounge, which would have been a bit embarrassing! I think the project was a logistical and organisational triumph. We had contractors sourcing materials from all over the globe, but it all went incredibly smoothly; we came in on time, and on budget," recalls Jeff.

Could a freak wind destroy the bridge? "Oh, that's an impossible question to answer. As soon as an engineer says something won't happen, the asteroids arrive. It would take an extreme natural event, the sort of thing that hasn't been seen for millennia. Certainly none of the blows in the recorded history of Hong Kong would be sufficient to shake it."

ENGINES DON'T
GROW ON TREES

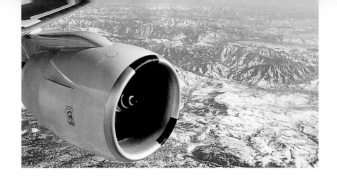

EMid

TRENT
FUEL EFFICIENT, LIGHTWEIGHT, LOW-COST JET ENGINE

ROLLS-ROYCE PLC

Ever since the Rolls-Royce Merlin engine roared out its distinctive growl from the long nose of a World War II Spitfire, the company's aviation wing has been a symbol of power, precision, performance and sheer class. The Trent engine, which has secured seventy per cent of the world market in wide-bodied jets, continues that tradition by taking the company into the 21st century well ahead of the competition.

"It's a three-horse race," says Keith Redfern, Trent head of marketing, "between ourselves, General Electric and Pratt and Whitney, but it's clear that airlines continue to prefer the Rolls-Royce option." It's easy to see why. The engine is significantly lighter than any competing product (almost four tons per aircraft lighter in one case), and therefore more efficient. So, it's the leader on performance and environmental grounds.

The key to this success is threefold. First, the engine's broad or "wide-chord" fan blades. Traditionally, the fan blades that you see in the mouth of the engine are reinforced with a ring that runs through the middle of the blades. This reduces aerodynamic efficiency by several percent – a vital statistic on long haul flights. But Rolls-Royce has come up with a way of building them without this reinforcement.

"We use two main techniques, super plastic forming and diffusion bonding," explains Keith. "Imagine a fan blade, around four feet long. Take three sheets of titanium. Shape them into a fan blade. Heat them until they become super-plastic, like Plasticine. Lay them on top of each other with a slight vacuum space between each layer. Then diffusion-bond them. That creates bridges of titanium between each sheet as the metal flows like plasma, making a web of connections. Cool the blade. You now have a girder structure inside the blade that is incredibly strong. The blade is much more resistant to impact from debris and

birds, and, because of improved aerodynamics and the lack of a reinforcing ring, the Trent is far quieter and much more fuel-efficient."

Secondly Rolls-Royce, "grow" the metal for the engine turbine blades like a crystal. This involves creating a mould, pouring the alloy, and then cooling it gradually in such a way that all the molecules line up to create a single crystal structure of immense strength. "We've designed the aerodynamics on the turbine blades so that they create a tight coat of cooling air which wraps around them as they spin. It means that the turbine blade can operate in temperatures of 1700°C – around 800°C above the blade's melting point," says Keith.

Thirdly, the Trent engine features Rolls-Royce's exclusive three-shaft design. Keith again: "The simplest way of explaining that is to imagine three concentric pipes. The inner pipe, or shaft, is the longest, connected to the wide-chord fan blades at one end and passing right through the engine. The next pipe is shorter, and drives the intermediate pressure combustion system. Behind that is the high pressure shaft. The point is that it is easier to transfer whole sections of the Trent, incorporating new and improved technology, to older engines like the RB211 and make them far cleaner and more fuel-efficient (the RB211 is also a three-shaft design)."

This modular design is also easier to reconfigure, manufacture and maintain, the three-shaft 'signature' being typically shorter and more rigid that the two-shaft designs of our competitors," continues Keith. "The Trent's modules may be scaled up and down to create bigger or smaller engines and that makes for large savings in development costs. Low weight, high thrust, low operating and maintenance costs mean that the Trent can carry 30 more passengers on a 777. And with multiple flights a day, 365 days a year, that's a lot of extra revenue."

DIY FLY

NE

EUROPA XS
SELF-BUILD LIGHT AIRCRAFT,
STORE IT IN YOUR GARAGE

YORK EUROPA AIRCRAFT LIMITED

Former airline pilot Ivan Shaw dreamed of having a light aircraft that you could keep at home in your garage. He wanted a two-seater that was fast, manoeuvrable and economical with fuel. And it would have low take-off and landing speeds so that you could use a field as a landing strip. But he couldn't find a manufacture making anything like it. So Ivan thought, I'll do it myself, and he did.

"I spoke to a lot of people about this idea," says Ivan. "Isn't it obvious that people want to keep their plane in their garage and take off and land in fields? Who wants to pay airport hangar rents all the time? But try finding an inexpensive two-seater to do that nowadays and you might as well whistle in the wind, because their frail little wheels would just snap off on the first bump!"

"People thought I was asking a lot of a little aircraft. I wanted it to go fast when it was in the air, which usually requires small wings, and to go slow when it was landing, which usually requires big wings, because you have to slow down to land on a field. Imagine driving a car across a field at 90 mph. You would smash it to bits. Forty mph and you might be OK. But I knew it was just a question of adjusting the aerodynamics," he explains. "Look at a jumbo jet's wing as it comes in to land. Bits start lifting up and down, foulers pop out and other bits extend in this weird robotic dance. The thing transforms itself from

a high-speed cruising wing into a large area landing wing in a few seconds."

"Well, as luck would have it, I happened to know Don Dykins, the recently retired technical director of BAe who had been the aerodynamicist of European Airbus. I got to him when he'd become fed up with no greater challenge than a round of golf, because he nearly snapped my arm off when I told him what I wanted! He became a partner and designed a wing that would do the business."

"The wheels were the next problem. I solved that with a retractable mono wheel that had a great big tundra tyre on it – excellent for leading the plane over the bumps and ruts of a meadow," explains Ivan. "We designed the Europa XS so that you could put the wings on, or take them off, in five minutes flat, making it easy to park the plane on a trailer in a garage. We made sure the plane ran on four-star petrol and the fuel cap was accessible. The Europa XS is more economical than a motorbike, doing 50 miles to the gallon. And it's whisper quiet."

"Now I can go out to the garage, hitch the plane and trailer to my car, fill up at the local petrol station, park in the nearest field and five minutes later be climbing into the sky with the South of France just a short flight away. And so can my customers."

GLOW LIGHTLY

FIRST GLOW
GLASS BEADS FOR LUMINOUS ROADS

**FORDINGBRIDGE,
HAMPSHIRE**

PRODUCT 2000 LIMITED

Cats-eyes – two beady eyes reflecting the lights of oncoming cars and marking the middle of the road – are often quoted as one of the great British innovations. Well, this is great for cars, but not so good for pedestrians or cyclists, of course, whose lights (if they have them) aren't powerful enough to reflect in the cats-eyes. Now we have First Glow, which means that the road markings not only reflect light, but give off a light of their own.

Managing director, Mark Barry: "We've been making thermoplastic road-marking paint for quite a while. Typically this is yellow or white paint which is heated up and put on the ground while still hot. Then we started thinking about glowing road-markings."

"People have tried to formulate glow-in-the-dark road-marking paint before, but it's never worked because it requires an awful lot of phosphorescent pigment, which is expensive," explains Mark. "So, we came up with the idea of mixing the pigment with tiny glass beads. You apply the paint onto the road. While it's still wet, you pour on the pigment-and-bead mixture. The pigment dust gets trapped between the beads and the wet paint. When it's dry, the pigment shines through the beads, which acts like prisms, creating a more three-dimensional lighting effect. And the beads reflect oncoming light. So it works both ways. It's a lot more cost effective than just mixing phospherescent pigment into paint, and in our view works better."

Not only in their view: First Glow is been lavishly applied to roundabouts, "sleeping policemen", zebra crossings, railway platform edges, car parks and fire escape routes.

"DRIVER, I'M FEELING A BIT FLAT TODAY"

NI **REMOTE TYRE PRESSURE
MONITORING SYSTEM**
TRANSMITS INFORMATION

ANTRIM SCHRADER–BRIDGEPORT INTERNATIONAL
INCORPORATED

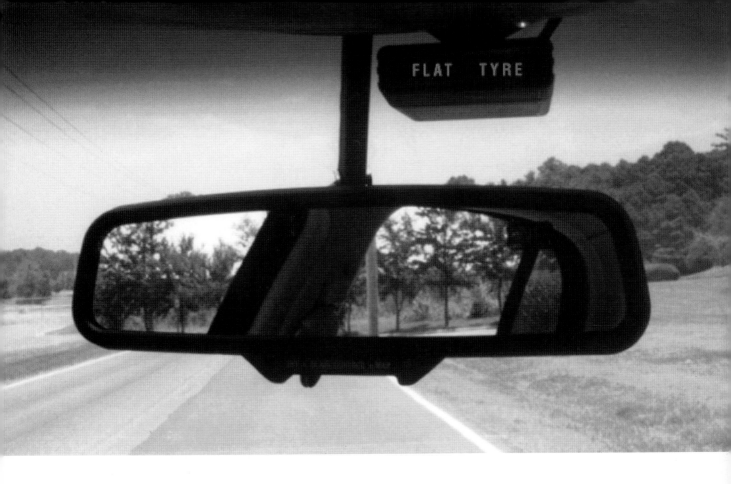

Don't forget to check the WOT. The what? The Water, Oil and Tyres. They're all messy jobs. UK garages sometimes supply you with gloves and tissue to do the dipstick bit, and most people can manage the water. It's the tyre-check that's the real pain. Firstly, you can never remember how many pounds per square inch goes into which wheel. And then you're down in the dirt, trying to connect the air-hose but it won't go on properly, and suddenly there's a sharp hiss and the tyre's flat...

Poor tyre pressure is not just a question of inconvenience. It can cause accidents, increase fuel consumption (around 4,000,000 gallons of fuel per day is wasted in the USA due to poor tyre pressure) and it reduces the life span of tyres. So, is it beyond us to come up with a dashboard read-out that knows the tyre pressure and tells you if more air is needed? Oh. Someone's invented one.

Schrader-Bridgeport, famous for its tyre valves, is the world leader in tyre pressure monitoring system, and Mark Williamson is their business development engineer: "An ASIC (application specific integrated chip) on the inside of the valve, takes an analogue signal from a pressure sensor, digitises the information and sends it via radio frequency to a dashboard display. The unit measures and transmits pressure more often when the vehicle is moving thanks to a built-in motion detector. The entire unit is battery powered and has a 10-year life span."

"We're the first to transmit tyre pressure data from the valve to the dashboard by radio link," explains Mark. "And our competitors are still trying to catch up," says Mark. Now the Chrysler Prowler and GM Corvette C5 are fitted with the system and there's growing interest from European car manufacturers and world-wide."

NW

CHECKPOINT & CHECKTAG
VISUAL MARKER FOR
WHEEL NUTS

MANCHESTER BUSINESS LINES LIMITED

When you change the wheel on your car, you probably crank the nuts up as tight as you can. You are insuring against the nightmare of losing the wheel at high speed. But how often after that do you check to see if the nut has begun to work loose? It's pretty likely you won't check them until the next wheel change.

This problem is more pressing the more vehicles you have. Industrial chemist Mike Marczynski found himself searching for a solution while he was running a small fleet of waste-disposal tankers. "The tankers have to go down some pretty bumpy tracks to get to the job," says his partner, John Marriott. "When tankers go off road the wheel nuts can work loose. Mike came up with a brilliant solution. If it had been me, an engineer, I'd have invented some elaborate nut lock, but he approaches the whole thing differently, perhaps because, as a chemist, he's used to seeing chemicals that indicate change. Mike came up with an indicator system that shows immediately if the nuts had moved."

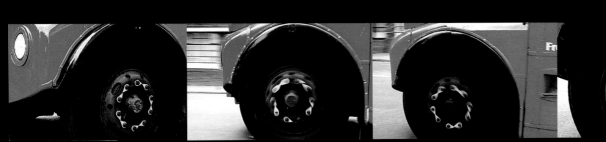

Mike Marczynski: "No one knows why wheel nuts come loose. It's labelled as something you live with – it just happens. And the trouble is you can't see if a nut has moved. Put one on the table. Turn it round. It looks the same. So I came up with a yellow plastic cap that pushes securely onto each nut. Each cap has an arrow on it. When you've tightened up all the nuts, you turn the arrows so they're all lined up. Then, all you have to do is glance at the wheels and you'll see immediately if one is working loose."

It's so simple it hurts. Why has no one thought of it before? "It's a great time-saver," says John. "We've sold hundreds of thousands in the UK, and we're doing well in Canada and the Sub-Sahara. Railtrack are considering using it now because they have teams of men walking the rail-lines tightening the bolts which hold the tracks together. If they could see at a glance that, say, just one bolt needed tightening, it would save them so much wasted effort."

They're also looking at using Checkpoint on the overhead electric cables," says John. "Sometimes the cables get blown down, and that can be due to loose bolts. The tags are made of plastic, so they're non-conductive. It means that you can introduce a new safety system across the rail network without having to make any modifications to existing infrastructure."

Business Lines has also developed a sister product, Checktag. John: "When you change a wheel, or swap it with another to even out tyre wear, you need to tighten up the wheel nuts again after around 50 miles. Most operators know this, but with vehicles being driven by different people and trailers being towed by different tractor cabs, sometimes the 50-mile tightening routine gets overlooked. Checktag makes sure you don't forget it. You put a Checktag on one of the nuts and its big red arrow tail acts as a vivid reminder that the nut hasn't been re-torqued. It brings to the front of your mind a problem that is too easily forgotten."

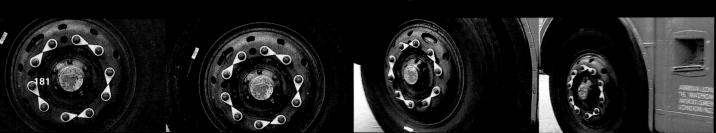

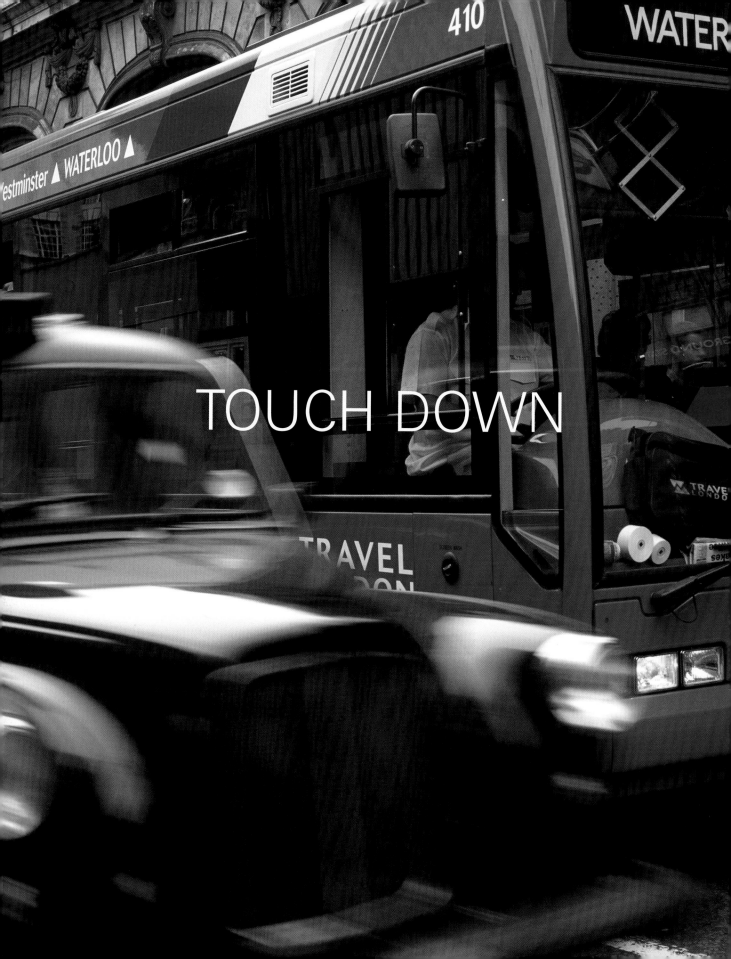

NE

SOLO
BUS DESIGNED FOR EVERYONE

LEEDS OPTARE LIMITED

Getting on and off buses with shopping – nightmare! Buses, shopping and a wailing child in a pushchair – Armageddon! Running for the bus, battling to get the shopping bags up the steps, through the narrow door and past the driver, while simultaneously folding a pushchair and lifting your struggling toddler up off the pavement as people in the queue tut-tut and the traffic starts to pile up – it's enough to make anyone go out and buy a car.

Wouldn't it be nice if, instead, a bus came whispering along, knelt down before you and humbly invited you aboard through an entrance broad enough to pass a car? A bus that had wide, wide seats to accommodate all sizes with room to spare, along with a spacious aisle, large tinted windows, cushioned suspension and brakes as smooth as silk...

David Hoy is Optare's export manager and was involved in the development of the new Solo "midi-bus": "No, honestly, it really does kneel down. The Solo is designed to meet all the conditions in the Disability Discrimination Act, so, apart from a stack of other features, it must be easy to roll a wheelchair off the pavement and into the bus."

So the front-end of the Solo kneels but, and this is bizarre, it sticks its tongue out too. When the driver spots a wheelchair passenger or a mother with a buggy in the queue, he can press a button which extends a metal tongue onto the pavement to make it easy to roll on

board. Because the bus has such a low centre of gravity, there is no need to lock the wheelchair into place once it's aboard. The chair's brakes are sufficient to hold it steady on the sharpest of corners.

So why, oh why, have we had to struggle up steps for all these years? "Because midi-buses were originally designed around small truck chassis, which is totally unnecessary nowadays," explains David. "The Solo came from the growing demand for smaller buses on rural and inner city routes, and the design came out of a long consultation process with our customers. By satisfying the requirements of the DDA, we've created a midi-bus that's more comfortable and easier to use for everybody. Wiltshire and Dorset bus company came to see the plans on the drawing board and immediately ordered 85 for their region and it's been selling very well since. You'll see them all over the country now. The design is quite unique, and the export potential is very high. We're planning to licence the technology so that people can build it abroad."

The wide entrance and that quick loading and unloading of passengers saves a lot of time. This means less traffic jams, less frustrated car drivers, less fumes, and more chance that the buses will keep to their timetables. It remains to be seen whether the new buses develop their predecessor's herding instincts – the famous public transport syndrome of nothing for ages, and then three come along all at once. But there is hope – after all, this one is called the Solo.

WMid

TX1
TAXI WITH THE MOST

COVENTRY LONDON TAXIS INTERNATIONAL

The London black cab is an internationally recognised icon – more familiar even than New York's yellow taxis. And you don't mess with an icon. But sometimes you have to. Safety regulations change and you have to change with them.

Jevon Thorpe is the managing director of London Taxis International and led the design team which took the Fairways and turned it into the TX1.

"We had to address the new Disability and Discriminations Act which insists on equal rights for all people. We had to abide by European approval, which among other things, ruled out the rear-hinged doors of the Fairway and insisted on more driver visibility plus there was another set of regulations from the Carriage Office to consider, some of which were in direct conflict. You'd have one lot saying the vehicle could only be so high, and another saying minimum interior headroom was considerably taller than that. One of the designers sent me a report illustrated with Dr Who's Tardis, saying the only solution was to alter the space-time continuum!"

A CAB FOR ALL REASONS

"The team was incredibly committed," recalls Jevon. "We lived and breathed this project, working late into the night – night after night. Cost me a fortune in pizzas. We pushed the wheels outboard, making the taxi wider inside, and pushed them further forwards and back, making it longer inside. We moved the cab over the engine block and pushed the rear seat back. We curved the top of the doors so they locked into the roof, making the vehicle high inside but lower outside – one early design looked like an ice-cream van! Now you can walk into a London cab."

"At every stage I asked, is it soft? Is it friendly? Is this a welcoming car? I was determined to keep the 'iconic', with its coke bottle lines, upright grill, instantly recognisable rear glass and side glass profile, teardrop rear lights and its shiny black roundness. These were the cues. The team thought I was barking. But I wanted to create a she-car, not a he-car," explains Jevon.

"Of course when the critics got hold of it, they called it the 'Noddy car' (as driven by Enid Blyton's fairytale hero)!" recalls Jevon. "But I didn't mind. As a kid I always wanted a ride in Noddy's car. And it confirmed that I'd managed to create the friendly taxi I always wanted. We're also proud that we created a steel-bodied car for just £20 million in just 28 months. Find me a car company that can do that. My father's been in a wheelchair for 50 years and I'm proud that this car is easy for him to use, and, as a consequence, easy for everyone to use. I'm also proud of the hidden features, the fold-down car seat, laptop power link and intercom system with an induction loop for hearing aids."

"Now I see people hailing taxis and trying to catch the TX1 rather than the Fairway," says Jevon. "The Fairway was good, but the TX1 is the most comfortable and roomiest general purpose taxi in the world. We're even exporting them to Germany."

What's next? "Zero emission taxis. We want to lead London traffic into using the new vehicle technologies. The TX1 complies with all the current regulations, but cities need more than that. They need truly green cars. But don't worry – our green cabs will still be black."

21ST CENTURY PEDDLE POWER

NW

THE PICKUP
PEDDLE-POWERED TAXI FOR NO EMISSIONS

ADVANCED VEHICLE DESIGN

Is this a serious proposition? A pedal taxi, a rickshaw with knobs on, ferrying people around the world's seething capitals, powered by people rather than machine. It's a gimmick, surely! A typically British crackpot idea.

Inventor Robert Dixon doesn't see it that way. And neither, no doubt, do his bank manager and customers. "This is a serious solution to a serious problem. I used to work in the distribution business, organising deliveries for companies, including the newsagents WH Smith and Sons. New anti-congestion regulations have been creating problems for deliveries. In many cities vans and lorries are banned from pedestrianised centres between 9am and 4pm, and it was becoming very hard to get deliveries made."

Then Robert was made redundant. But instead of panicking, he turned his full attention, and redundancy pay-off to solving the problem of daytime deliveries. "I wanted something that was totally green so it wouldn't be affected by emission and noise restrictions, and that could carry a Euro-palette, or 1.8 cubic metres of load. I looked to Asia and saw how much freight was moved around with bicycles, and decided to redesign the rickshaw," recalls Robert.

"I decided on four wheels for stability, and put the driver into a comfortable semi-recumbent position, which gives more power to the legs. Also, I took advantage of new cycle transmissions. I went for a seven-speed hub gear because with one of those you can romp along in seventh gear, stop, and change to first without going down through all the gears."

"I designed a coupling to articulate the chassis so that it could handle uneven ground, and that makes it much easier to drive. I also invented a lightweight compact differential, which is essential on four-wheel vehicles because it allows for easier cornering."

Robert explains: "As you go around a left-hand corner, the left-hand wheels travel less distance than the wheels on the right which describe a wider arc, like runners sprinting round the outside lane on a track. So the outside wheels have to turn faster than the inside wheels, just as runners going round the outside track have to sprint faster to keep up with those on the inside. A differential is usually a large, heavy affair, so it was essential to miniaturise it."

"I've designed three versions of the vehicle – a pedal van, a pedal truck with an open back for palettes and hay bales, and, of course, the taxi. One human can carry two passengers fairly easily at a steady 14 mph, well above city centre speeds. For hills I've added an electric motor to assist during the climb."

Now there's a small fleet of yellow pickups running in London and Robert's discovered a lucrative plus. "Companies like to advertise on the Pickup because everyone looks when one goes by. The US Mail are doing trials on the van version, and so are the courier service, TNT. Deals are upcoming in Rome, Turin and Philadelphia, and we've been commissioned to design a golf buggie, which won't damage the greens."

"People think I'm nuts, but that's because Britain is taking its time to come around to the idea. We export eighty per cent of our production," explains Robert, "...and in places like Hamburg and Munich they don't bat an eyelid. I guess they're used to clean human-power. I don't sell the Pickup simply on the green ticket, but rather because it's a very sensible and commercial solution to the problem of getting goods and people around modern city centres. Its environmental friendliness is the added bonus."

BIKE HIKE

SW

CYCLE ROUTE MAPS
INFORMATION FOR CYCLISTS

BRISTOL SUSTRANS

It's the truth. We should cycle more...fix that five-year-old flat tyre, get the bike on the road and pedal up that hill. We could all get fit. Make it a new millennium resolution. But start in East Anglia, where it's generally flat, before working up to tackling the strenuous hills of the West Country, North Wales or the Highlands. Sounds like a long hike? You've only just begun. When this book went to press there were 5,000 miles of cycle route in the UK now, thanks to Sustrans.

Sustrans grew out of a lobbying movement to build traffic-free paths to encourage people to walk and cycle. Philip Insall, editor of the National Cycle Network Map series: "Our objective is to bring about a change in transport culture in the UK. With that in mind we put together a project for a long-distance route from Dover to Inverness. The reaction took us aback – people all along the route were incredibly keen. We realised that we'd touched a nerve and started drawing up plans for a national network of cycle routes."

"Inspired by a visit to the launch of the Danish national cycle network, we began planning 5,000 miles, running through both countryside and heavily populated areas, and also began to consider how we could fund it," recalls Philip. "Then the National Lottery came along, and with that suddenly the dreams became possible. We now co-ordinate the creation of safe cycle routes all over the UK in co-operation with 400 partners, including local authorities, cycle clubs, community groups, major landowners, the Forestry Commission and British Waterways. We aimed

to have 2,000 miles by 2000AD and 5,000 by 2005. But such has been the public's enthusiasm, we actually completed 5,000 before the millennium."

"After we created a map for the award-winning C2C (sea-to-sea) route across the north of England (our first long-distance route), we realised we needed special maps," explains Philip. "That 140-mile-route was hugely popular and the influx of thousands of cyclists gave a welcome boost to the region's tourism. But we made a dreadful job of our first map."

"So we started talking to cartographers and selected Sterling Surveys to publish the C2C route in the style of their Footprint series, which is designed for ramblers. The cycle maps incorporate information on both traffic-free and on-road sections, using a directional, fold-out strip-map format."

"We worked with Sterling Surveys to adapt the style for the needs of bike travellers. Cyclists' speeds vary between walking pace and around 20 mph, so a 1:100,000 scale is optimum, though we use a sliding scale to make the information clearer in urban areas. We print on waterproof paper, and include features of specific interest to cyclists such as the gradient of a given route, and warnings of any dangerous sections. The maps have been very popular and have received a couple of awards – one from the British Cartographic Society, while the coast-to-coast route won the US travel industry's Smithsonian Environmental Award in 1998," says Philip.

EASY DOES IT

"LEARNING TO TAKE A PRODUCT TO MARKET IS EASIER IF YOU
MAINTAIN CONTROL AND DO IT GRADUALLY. IT'S JUST LIKE
LEARNING TO RIDE A BIKE." DAVID GOOD

Wa

LLANDEGFAN, ANGLESEY

**BALANCE TRAINER
BICYCLE STABILISERS**
ADJUSTABLE FOR GRADUAL LEARNING

GOOD DESIGNS

As easy as falling off a bike. Any child learning to ride can tell you how easy that is, and any parent who's picked their screaming five-year-old off the pavement will tell you the value of stabilisers. But they will also tell you that stabilisers create a false confidence and, when you remove them, the whole learning process begins again.

Think of a problem and then double it. David Good has twin sons. One, Simon, was a typical five-year-old, raring to go and determined to ride his new bike without using stabilisers. The other, Jeremy, was just as determined. But he also had hemiplegic cerebral palsy, which meant his whole left side was debilitated. Soon Simon was pedalling away, leaving Jeremy struggling in his wake. David Good: "It was very distressing. For many months I ran behind Jeremy holding his bike seat, encouraging him to keep on trying. But he just couldn't balance."

David was a design engineer for the NRA (renamed the Environment Agency). "Designing flood protection schemes and sea defences requires a lot of lateral thinking because most often off-the-cuff solutions don't exist." David applied his lateral thinking skills to the problem of Jeremy's bike riding. "I believe that many cerebral palsy victims can learn all sorts of things so long as they are taught bit by bit," he explains. "So I came up with the idea of adjustable stabilisers, with wheels that can be moved closer to the back bicycle wheel in gradual stages. I made a set for Jeremy and gradually narrowed their spread over two months. Then one day I suggested that he try his brother's bike. He was off. We've got photos of him riding round the school in Anglesey with a great smile on his face. It was a very emotional moment."

Jeremy's physiotherapist suggested that David make more stabilisers for children with poor balance due to various disabilities. He did, and they were gratefully accepted. So David then made another breakthrough. Instead of taking his idea to a series of manufacturers and having it ridiculed and rejected like a thousand inventors before him, he studied the market and used £10,000 of his own savings to secure a patent and commission an engineering company to make the product. He sold hundreds of sets to the disabled market, and is now selling the new version, Balance Trainer, to bicycle shops around the UK, with the intention of helping all children, disabled or not, to learn to ride a bike.

SWEET DEAL

Lon

LONDON

DIVINE
A CHOCOLATE BAR THAT'S FAIR TRADE & MAINSTREAM

THE DAY CHOCOLATE COMPANY

Divine by name, divine by nature. The Day Chocolate Company is part owned by Kuapa Kokoo a group of small-scale Ghanaian farmers who grow the cocoa beans which make the chocolate. Their partner is Twin Trading Limited, set up by the Greater London Council in 1985 in order to encourage trade with developing countries for mutual benefit, and which brings the fair trade coffee, Cafédirect, to Britain's high streets.

Company project director for The Day Chocolate Company is Pauline Tiffen: "This is the first time that African growers have owned shares in a British company in this way," she explains, "...and it is in total contrast to every other mainstream chocolate venture in which the farmers live and work a long way away from the profits and marketing message. These farmers want their customers to enjoy the product, and it's important to them that Divine is the best tasting chocolate in the world."

"Divine chocolate contains no synthetics or vegetable fats – we use cocoa butter instead. Neither is there any genetically modified lecithin emulsifier. It contains more cocoa than most milk chocolates and real vanilla, so it tastes great."

Day produces a quality product which is not detrimental to either the farmer or the planet. "Day aims for cocoa production to be sustainable," explains Pauline. "By that, we don't just mean that our system is 'technically' sound. For us, a good relationship between people in the North and South is paramount, because we're keen to build better prospects for everyone involved."

Divine is on sale throughout the UK in both small shops and large supermarket chains, and it's also available in the USA and Canada. Being within easy reach of shoppers, giving them the choice and the chance to take the fair trade option, is a major challenge for a new brand in such a saturated market. Buying Divine means that in a small way you can be part of a solution to the world's economic dilemmas and not part of the cause!

STORE DETECTIVE

SW

INSIDETRAK
VITAL INGREDIENT FOR SHOPPERS

POOLE, DORSET TELXON LIMITED

How do you know what's in a tin? You read the label, of course, but there's a reasonable chance that you'll be none the wiser for doing so. Because even if you do understand the E-numbers and the chemical compounds, if the ingredient you are looking for is below a certain percentage, it doesn't have to be listed on the label at all.

There are all sorts of reasons why it would be good news to have complete access to food ingredients. Allergic reactions are one. Losing weight is another. Moral, religious, political, scientific or social objections are yet others – GM foods being a controversial case in point. But the truth is that there simply isn't enough room on the label for every detail.

And yet supermarkets generally do possess the full story on their products. That information is supplied by the manufacturers electronically and is stored on the shop's computer. So how do you get the information out of the computer and onto the label?

Dave Spokes is marketing manager for Telxon Limited: "We've come up with a software solution called Insidetrak. This runs on the shop's computer and on a computer/ scanning device that you pick up at the entrance and carry around or clip to your trolley. Every time you take something off the shelf, you run it past the scanner and

up pops information about the product on it's screen. You can then decide whether you want to put the product in your trolley or leave it on the shelf."

"What's happening," he explains, "is that the device is interrogating the supermarket's computer by radio link and giving you all the information it has. So if you've got an allergy to dairy products, Insidetrak will tell you if a product contains any traces whatsoever. You don't have to read through all the information either. You can programme the system with your requirements, say, an allergy to dairy products, and each time you scan an item that contains any, an alarm will sound and a warning is displayed."

Dave says the system can also include software which totals up your purchases and allows you to pay without having to re-scan all the products at the check-out. "This is the first time a computer system has managed to give you such a full interface between the shopper and the shop. Information can flow in both directions."

The system also allows the supermarket to offer you personal discounts and services based on your previous record of purchases: "Ah, Miss Jones, you haven't bought a bottle of wine for over a month. How about this rather impudent little Claret for a bargain price?" Don't mind if I do. Cheers.

NEXT CENTURY'S MODEL

**NON-IRON COTTON, NON-POLISH SHOES
WASHABLE WOOL, BODY SENSOR TIGHTS**
LESS WORK, MORE WEAR

LONDON MARKS & SPENCER PLC

We live in a rush-rush society. We can't get out the door quickly enough in the morning. Most of us don't want to polish our shoes, iron our clothes or dry-clean our suits. We'd prefer that they did it themselves. Well now, just in time for the 21st century, they do.

Marks and Spencer, the classy purveyor of TV-dinners and knickers, knows its target market. People on the move, too busy working or living it up to bother with chores. So they've generated a collection of Millennium Products to make lots of people's lives much easier.

Their non-polish footwear, made in partnership with UK-based Porvair, uses leather coated with a thin, durable, breathable polymeric film that is scuff resistant, stain resistant and water resistant. You just wipe it over with a damp cloth – if that isn't too much trouble.

Can't be bothered to take your woollen coat down to the dry-cleaners? Or perhaps you haven't reclaimed the last one and you're a bit embarrassed? Most likely, you don't want to wait three days before it's done. Well, M&S have come up with the first one hundred per cent wool clothing (jackets, skirts and trousers) that don't need dry-cleaning. They promise that these products can be washed and tumble-dried and will, "require only the minimum of ironing to regain their pristine appearance".

Oh, but you hate ironing. Not to worry, M&S knew that too. Now ironing is banished thanks to their machine-washable non-iron cotton trousers and shirts. And, if you don't have a tumble drier, they air-dry perfectly.

So there you stand, in your non-polish footwear, your non-iron shirt and your fetching, washable, tailored woollen jacket and skirt. Well, it's winter after all. But your legs! Aren't they blue with cold? Of course not! Because you're wearing Marks and Spencers' new Bodysensor tights, which "keep you warm when it's cool and cool when it's warm", by allowing moisture to escape quickly if the temperature rises...No sweat and no fuss.

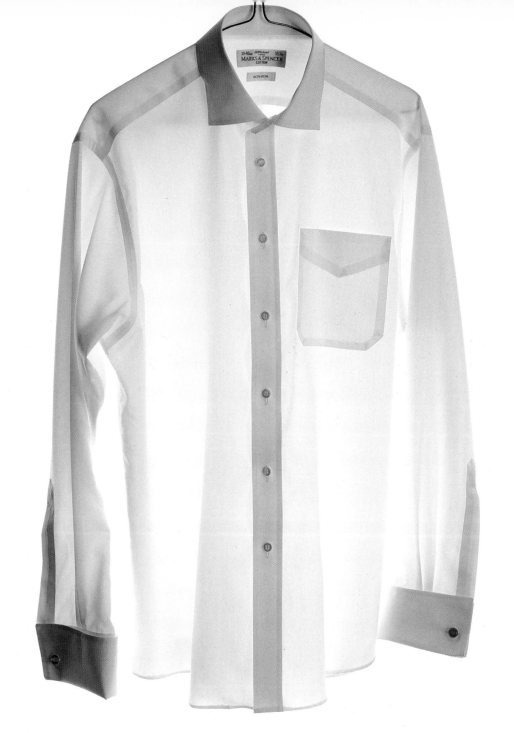

NON-IRON

39-40 cm	**15** $^1/_2$
WHITE	
COTTON	
MP No:	1199

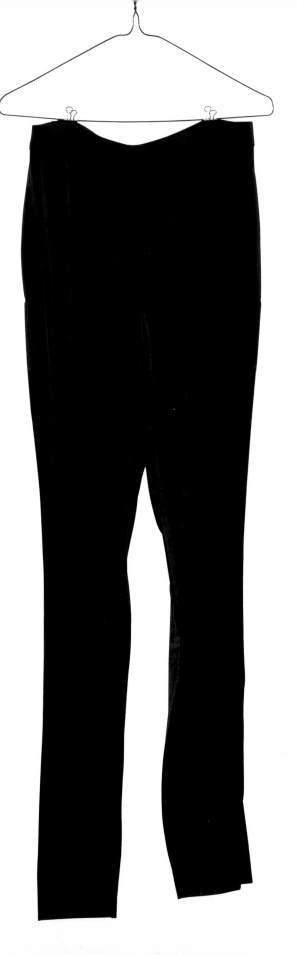

NON-IRON

UK • 12	EURO • 40
BLACK	

WAIST	LENGTH
67cm 26in	89cm 35in

| MP No: | 1199 |

NON-POLISH

UK • 9	EURO • 43
BLACK	
T04/0119/1624K	
MP No:	1209

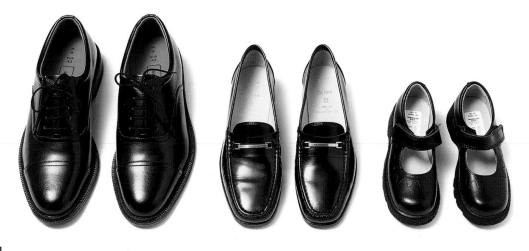

WMid

STRATFORD-UPON-AVON, WARWICKSHIRE

TELETUBBIES
PRE-SCHOOL EDUTAINMENT

RAGDOLL PRODUCTIONS (UK) LIMITED

When the Design Council selected *Teletubbies* as a Millennium Product, the media was furious. Leader writers and television commentators have called the decision "irresponsible" and "ludicrous". While no one could deny that *Teletubbies* was perhaps the most successful television programme in the world, it was the claim that it was innovative, pathfinding, and a great example of British creativity that they found so hard to stomach.

Writer and co-creator, Andy Davenport: "To many adults, *Teletubbies* looks aimless. The story-lines seem too simple. There's lots of repetition, lots of time in which nothing seems to be happening. But the programme's critics don't understand the way that very young children see the world. I write *Teletubbies* so that it communicates with children in their own language. That's why they enjoy it."

Co-creator and producer Anne Wood: "I was surprised by the vehemence of the criticism. It seemed to be coming from people who saw young children as vessels that needed filling up with traditional education rather than lovely, happy beings to whom the world is a constant wonder." Anne is a remarkable woman. She saved ailing breakfast-time television station, TV-am, with a glove puppet called *Roland Rat*, boosted Central's profits with *Rosie and Jim* and won two BAFTA awards for *Tots TV*. She then put her company, Ragdoll Productions, on the line to produce *Teletubbies*. "We spent a long time watching how very young children reacted to our programmes – partly by putting video cameras on top of their television sets and filming their responses. We learned the best ways to communicate with a young audience and we learnt how they understood things and what they enjoyed."

"Repetition is extremely important to this age group," says Andy. "One of the first things that children learn to say is,

again! again!" They need and gain pleasure from repetition because it is a vital learning tool. So *Teletubbies* repeats whole scenes, helping the children to become familiar with all aspects of the action. When they are so familiar with it that they can predict what will happen, the 'joke' dawns, and then something unexpected happens. This is the foundation of humour. Even parents smile."

"*Teletubbies* is about fun and about helping children to enjoy the world," explains Andy. "They gain great pleasure just from watching Tinky Winky coming towards them, over the hills, down the dales, getting bigger and bigger, popping up or disappearing in a giant game of peekaboo. This is because, at that age, they are fascinated by spatial events. It's incredibly stimulating for them to see characters moving around in an interesting environment. But the key is getting the timing right – if you didn't then it would be deeply boring."

The first major children's programme to target one- to three-year-olds, *Teletubbies* is a triumph in terms of communication. Hugely popular in the USA and around the world, it transcends language barriers, and experts now see it as a pathfinding teaching tool. Talk to almost any parent and they'll tell you how amazed they are at their child's reaction to *Teletubbies*.

"We've received so many letters from mothers saying that *Teletubbies* has helped children respond and laugh when before they were silent," says Anne. "*Teletubbies* is about a colourful, gentle, happy, non-violent world, and children learn about this world through the language of laughter."

Innovative, radical and a great example of British creativity? Of course. But *Teletubbies* is also, ahead of its time, which is, perhaps, why some commentators still fail to recognise its true value.

PO

AGAIN! AGAIN!